Actually . . . I Met Them

A MEMOIR

GULZAR

Translated from the Bengali by
Maharghya Chakraborty

PENGUIN
An imprint of Penguin Random House

HAMISH HAMILTON

USA | Canada | UK | Ireland | Australia
New Zealand | India | South Africa | China

Hamish Hamilton is part of the Penguin Random House group of companies
whose addresses can be found at global.penguinrandomhouse.com

Published by Penguin Random House India Pvt. Ltd
4th Floor, Capital Tower 1, MG Road,
Gurugram 122 002, Haryana, India

Penguin
Random House
India

First published in Bengali in *Panta Bhate* by Dey's Publishing in 2017
First published in English in Hamish Hamilton by Penguin Random House
India 2021

ISBN 9780670096077

Typeset in Adobe Garamond Pro by Manipal Technologies Limited, Manipal
Printed at Replika Press Pvt. Ltd, India

www.penguin.co.in

Dedicated to

The very first person . . .
Sanchari Mukherjee

Contents

Foreword

The book is in the first person. That is largely due to the fact that I narrated everything. However, there are three first persons in this book.

I first shared my thoughts with Sanchari for a Bengali newspaper's Sunday edition. She would fly down to Mumbai and cover the columns for two such editions at a time. I spoke in the first person, in Hindi, Bengali, English and Urdu; she framed all of it in good Bengali.

Finally, a compilation of these narratives was published as *Panta Bhate* in Bengali.

The book has now been translated from Bangla to English by Maharghya Chakraborty. But, again, in the first person, as I narrated.

Hence, there are three generations of first persons. From Hindi to Bengali to English, this was an amazingly interesting journey. Having said this, I remain the 'First Mujrim'.

I wish to dedicate this book to the very first person, Sanchari Mukherjee.

It seems like a dream when I revisit my memories of such great gurus and colleagues, and I feel overwhelmed that I have really interacted with them. I have to pinch myself on realizing that 'Actually . . . I met them'.

Gulzar
August 2021

Bimal Roy

Truth be told, I am as much a Bengali as I am a Punjabi, born as I was in a Punjabi household. Tagore caught hold of me, or it was I who caught hold of him, when I was in class eight. Ever since then, I cannot say for sure if it was the Bengali language that possessed me or I was the one who possessed it. By the time I passed my tenth standard, I was acquainted with the works of Tagore, Saratchandra Chattopadhyay and Bankimchandra Chattopadhyay through their Urdu translations. Listening to my Bengali friends in school talking in Bengali further tempted me to start learning the language. And so I did. Simultaneously, my forays into literature continued as well. It was around this time that I began to wish to be a writer. When I was in St Stephen's College, I was sent off to Mumbai (then Bombay) where my elder brother used to live. It was perhaps to ensure I learnt how to make a living and not waste my life away on trivialities.

It turned out to be a blessing. Soon after moving to Bombay, I joined organizations like the Progressive Writers' Association (PWA) and the Indian People's Theatre Association (IPTA). The people there, their preoccupations and the sharpness of

their intellect, their energetic debates, all of these began to work on me like a drug. Besides, there were two more things that I did. Firstly, I moved out of my brother's place because he and my literary proclivities were clearly at odds with each other. And secondly, I took up a job at a motor garage in order to make ends meet. At that time I used to live in a locality called Chaar Bangla. It was around then that I made many more Bengali friends. I also got further attracted to Bengali poetry. Whenever I had time, I would sit beside my window and translate poet Subhash Mukhopadhyay's poems.

Soon Debu Sen, assistant to renowned film director Bimal Roy, moved in with me as my roommate. Of course, by then we were all part of a brotherhood already, courtesy the IPTA—Debu, Salilda, Prem Dhawan, Ruma Guhathakurta and I. In addition to this, I was a part-time struggling writer as well.

Debu would return home and tell me stories about Bimal Roy. Sometimes I would accompany him to the studio, to watch movies on the Moviola editing set-up. Bombay was effervescent with the name and renown of 'the Bimal Roy' at that time. I had a separate personal interest in Bimal Roy's works. Since most of his films were adaptations of Bengali literature and I was a literature nerd through and through, I had an extra measure of respect for him. One day Debu said to me, 'Come, let me take you to him tomorrow.' Although I was awestruck at first, on second thought I refused the offer. 'No, I don't want to go. I won't be working in a film. So what's the point in going to meet him? I am going to be a writer.' The scolding came from the famous lyricist Shailendra. 'What do you think? Those who

work in films are all illiterate? Just because he wants to work with Bimal Roy, Jhalani (Roy's other assistant) is learning and doing his post-graduation in Bengali. And here you are getting an offer without breaking a sweat and you're not taking it?' I went to meet him for an assignment to write the lyrics for one particular song that Shailendra had meant to write. Due to a fallout between the latter and S.D. Burman, that was not happening anymore; so, I was chosen instead.

And so I went. Not only was the glitz I had expected to be dazzled by on entering Roy's luminous circle not there, but I also met such a decidedly simple and unassuming man that for a moment my heart did not know how to react. Debu said, 'Bimalda, my friend Gulzar.' 'Hmm,' came his reply. This was

Bimalda's famous 'hmm', the one that could be applied to any emotional moment, be it anger, love, annoyance, pain or worry. It was always by gauging the 'hmm' that we used to decide on our course of action or, for that matter, everything else. And wasn't that a difficult task! But those who knew Bimalda never took very long to figure out the meanings of his 'hmms'. The sentence following the 'hmm' was in Bengali and directed at Debu. 'Can the boy understand and write Vaishnava poetry?' 'Bimalda, Gulzar can understand Bengali, and he can speak as well.' Bimalda had gone red with embarrassment. I have never been able to forget the look on his face that day. Now when I think about it, Bimalda used to get embarrassed quite often. He asked me, 'How did you learn Bengali?' 'I learnt it from friends and then I read things by myself,' I replied. 'Can you read?' 'I can, I can write a bit as well.' 'Have you read *Kabuliwalah*?' 'Yes, I have,' I said, 'first in Urdu, then in English and then in Bengali.' It was decided I was going to write the song.

One day Sachinda, Bimalda and I got together for a discussion. Bimalda was explaining—'So you see, the girl never leaves her house. People come to see her father, they read Vaishnava poetry at these meetings. The girl hears these songs and gets inspired.' Suddenly, Sachinda interjected excitedly. 'What are you saying! How will it work if the girl never leaves the house? That's not how I have composed the music. No! You must make her go out!' We were stunned! Sachinda was talking about the character, insisting she go out. 'Tell her to go out.' But Bimalda wouldn't let her. Sachinda kept saying, 'I'm telling you, let her go out.' Bimalda replied, 'What are you

saying korta!' To ask my character to go out?' Sachinda seemed to finally lose his temper a little. 'If that's the case then you may as well ask Salil to compose the music.' By then Bimalda was trying his best to suppress his laughter. Paul Mahendra, one of the writers of the film, spoke up. 'Bimalda, how is the girl supposed to sing a romantic song in front of her father?' At once, Sachinda clapped his hands, 'That's it!' He had found someone to bolster his side of the argument. So, there they were, two seniors arguing over a song sequence, almost fighting over it, while we juniors listened on. This nit-picking was something truly worth learning from. The song was *Mora gora ang lei le . . .* (Take away my fairness and . . .). It was written for the film *Bandini* and was filmed on Nutan.

Bimalda believed he was not very good when it came to directing song sequences. Consequently, he worked on every such sequence with so much attention to detail that they became exemplary. If in the middle of a song a musical arrangement was changed or a new one introduced, he would immediately say, 'Change the shot. How can the rhythm or the instrument remain the same in the shot?' It was in his films that soundscapes were first used. A ringing bell or a barking dog, every sound heard during a song would be captured in Bimalda's soundscape. He was a man whose life revolved around cinema; he lived and breathed films.

· The word 'korta', which can somewhat be approximated as 'honourable sir' in English although in a far less formal manner, was a common term of address among Bengalis. The use is archaic now.

Once it so happened that we were working double shifts over a number of days. On one such day our work got over at ten in the night. As we were preparing to head home, Bimalda summoned Madhukar, the editor. 'Okay, so now you can go and make the tracks.' Madhukar was livid. Not that he dared say anything in front of Bimalda; nonetheless he kept on grumbling in annoyance. 'Neither does this man have a family life of his own, nor will he let us have one. I should have warned my wife! Don't marry me, I'm Bimalda's assistant.' Immediately after this, Bimalda called me. 'Goljar!' Yes, that's what he used to call me, pronouncing my name in that typical Bengali way of his. He called me and said, 'You stay with Madhukar and help him.' Our faces fell; we were left with no choice but to comply and keep working. Suddenly, around two in the night, the telephone in the editing room rang out. On the other side we could hear Bimalda's excited voice—'That point in the track where the lizard can be heard, just leave a white piece there and let it be. I have just recorded a lizard ticking. It's come out excellent. Tomorrow morning we will develop it and put that in.' It was not just us who were working after a double shift, Bimalda had been just as busy. For him, living life meant living the movies.

When my father passed away, I was expectedly busy with a film. In fact, I did not even receive the news in time. Four days later I received a postcard from one of our neighbours in Delhi who had found it rather odd that I was missing during my father's last rites. 'He is not the kind to not turn up at his father's funeral. Write him a letter,' he had told his son. When I read the letter it felt as if my insides were being torn apart in anger, hurt

and pain. I felt cheated. No one in my family had informed me. I approached Bimalda and he immediately got his manager to book my tickets for Delhi. I went to Delhi, met everyone and shared their grief. Only my father was no more. Nothing could assuage the hurt I felt at my family's behaviour. I returned to Bombay and the upheaval in my heart gradually quietened to a giant bubble that remained lodged somewhere in my heart. I threw myself into work again.

At work I laughed, joked around and got scolded. It was becoming obvious that Bimalda's influence over me was slowly growing. It was a comforting feeling even though nothing in his behaviour made anything apparent. It was just that there was an invisible connection between us somewhere and perhaps a bit of partiality as well. If one reason behind that was my desire to become a writer, the other was surely my affinity for Bengali literature. Meanwhile, my sister's wedding was finalized and I approached Bimalda for a couple of days' worth of leave. Bimalda replied, 'Hmm. Go and assist in the edit.' Dejected, I did as I was asked. A few days later I asked him again and yet again he replied, 'Hmm, go and list those sound effects.' Just as before, ashen-faced, I was turned away. Then one day I saw Jhalani, Bimalda's chief assistant, approach him with a similar request. 'It's my wedding. I need a leave.' 'Hmm,' replied Bimalda, his face impassive. The next day I ran into Jhalani on his way out, luggage in tow. Agitated, I asked him, 'But Bimalda didn't say yes!' 'It's my own wedding, brother! And in your case it's your sister's. If I don't turn up, the wedding won't happen. Bimalda's hmms will go on and time will run out. I'm going.'

Further dejected, I returned to work. A day before my sister's wedding, Bimalda called me and asked his manager to get me plane tickets to Delhi. 'And listen Goljar, you must return within two days after the ceremony. There's a lot of work here.' I was astounded, amazed and deeply moved. Did he really need me so much? Plane tickets! And this was in the sixties!

After the wedding I returned to Bombay and promptly got back to work. Besides other work, Bimalda and I were also simultaneously working on another project at the time: writing a script for *Amritakumbher Sandhane* (The Quest for the Fountain of Youth). He had made me read the book a number of times to ensure the script turned out strong. We would debate and argue just as much as we wrote. Bimalda had made

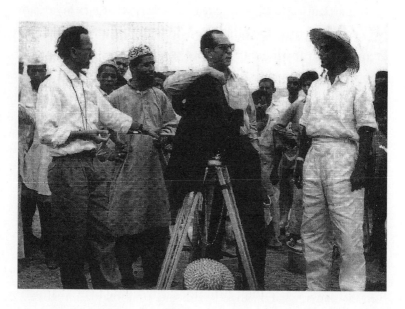

so many notes along the margins of the original book that those could be used to write an entire new book. Plus, there were the loose sheets of notes. I used to joke that the book was pregnant with a book of its own. One day while discussing the script we came upon a detail from the book that neither of us liked. A character called Balaram was to die right in the beginning, on the very first day of the fair as depicted in the novel. Bimalda was not convinced. 'How can this be, Goljar? The ritual bathing is after eight days. If this character dies right on the very first day then the screenplay will never be nice and compact.' I offered a number of suggestions but none of them seemed to satisfy him. This was around the time when we had just begun shooting a film called *Sahara*, based on a novel by Ashapurna Devi. It had been decided that after wrapping the shoot at hand, we were going to begin filming *Amritakumbher Sandhane* in the Purna Kumbh fair of 1966. One day as a shot was being prepared, Bimalda explained everything to us and headed downstairs. After the cameraman Kamal Bose was done readying the shot, I was asked to go fetch Bimalda. I went downstairs and said to him, 'Dada, the shot is ready.' His head lowered, Bimalda paused for a moment and then said, 'Tell Kamal to take the shot.' A spasm shot through my head. What was happening? The man who had never missed a shot even once was asking me to tell someone else to complete it! I went back upstairs like a robot and informed Kamalda about what Bimalda had said. Kamalda did not believe me, because there was nothing to believe. He went downstairs himself and repeated what I had said to Bimalda. 'You take the shot, Kamal,' came the reply. We were all silent. Someone

seemed to have hung an invisible icy sword over my head all of a sudden. Kamalda did as he was asked and we went ahead with the shot; Sharmilaji was in the scene. Barely a second had passed into the shot when we heard a voice from the back. 'Rinku, first walk back and catch the light.' Bimalda's voice. Finally!

But that was the last time he walked out of the set, never to return again. A few days of fever, a few days of being unwell, and then it was as if someone had plunged a dagger into our hearts. Cancer. Sudishda, Sudhish Ghatak, Ritwik Ghatak's older brother, used to be Bimalda's confidante. We asked him if the latter knew about the prognosis and found out that he did not.

Tea and cigarettes, the two things he loved the most, were taken away from him. Bimalda was soon taken to London for treatment but had to return without any hope. Nevertheless, that did not stop him from fussing over the screenplay of *Amritakumbher Sandhane*. I began going to his house to work, and after much struggle and effort managed to shift Balaram's demise from the first day of the fair to the fifth. I used to argue with him even then, although every time I did so I could feel a wave of pain coursing through me. Will I not be able to see him in a few days? Nevertheless, work never stopped. One day Bimalda called me and asked me to go and film a few shots of Allahabad since he would not be able to do it himself. I did as I was ordered, Kamalda and I. But during those seven–eight days of shooting, the two of us hardly spoke a word to each other. What could we have even said? I knew what was to happen, so did Kamalda.

We returned and that very day went over to Bimalda's place and finished whatever work we had. But I could not go back to visit him again after that. Bimalda seemed to have shrunk, gotten smaller, like a cushion on the sofa. I was not a hero, I could not stand seeing him that way. A few days later I got a sudden phone call. An excited voice at the other end, someone who sounded like Bimalda. 'Goljar! Come over right now. I have things to discuss about *Amritakumbha*.' By then I knew the film was never going to happen. Bimalda was not going to be there for long. But he was my guru; I had to go. He told me excitedly, 'Balaram will die on the day of the ritual bath. The first death. And that's where the stampede scene will start.' I heard everything he had to say and yet again came away with the sensation of the cold metal poised over my head.

8 January 1966, Bimalda passed away. When I heard the news, my first thought was that the swinging blade had finally dropped. I regained my senses with the feeling of a knot of pain. I rushed to Bimalda's house and from there to the crematorium. There, the nascent but very active bubble long hidden within my heart finally burst. With a bang. I cried and cried and then cried some more. With his passing, all the pain that I had stowed away for my father seemed to find closure. It was the day of the ritual bath of Purna Kumbh.

Salil Chowdhury

The kind of intoxication and energy that bursts forth when you shake and uncork a bottle of champagne—Salilda was that kind of a person. His life force and its verve were always poised like a champagne bottle, shaken and about to pop. Just as light spreads everywhere, Salilda came to be infused in our very blood and in our lives. I knew him from before I joined films, thanks to the Bombay Youth Choir and IPTA. Salilda was a member of the Communist Party of India, a music composer and a skilled organizer. His songs were popular, as much as they were always under the threat of being banned. He could be in jail one moment or underground the next. I was mesmerized by him, charmed too. My head would tilt in reverence when faced with the genius of an organizer like him. Ruma (Guhathakurta) had started the Bombay Youth Choir, and she was an extremely efficient person. Salilda was there with her, teaching songs, conducting rehearsals, taking people on tours with the Choir or IPTA. Those were the days when life brought you both hunger and pearls, when a rebellion did not exclude the possibility of a primrose path, when both Salil Chowdhury and I could just stroll past a slum in Bombay.

When I got to know such a person from close quarters, I realized that he was extremely indolent. He loved playing carrom, could always be found busy around the ping-pong table, always ready to do anything except his own work. But then he touched a piano or a harmonium and music would spill over like nectar! Oh! Such a genius, yet how could he live like that? Or perhaps it was possible precisely because he was a genius. His lethargy, his limitless talents, his thoughts which flowed like a river, terrible fretfulness, immense life force and an exciting life—how could one explain such a mixture if he was not a genius!

Yet, such a prodigy would spend most of his days at Mohan Studio playing carrom. With such an important task to do in life, why did anyone ever goad him into making music I can't say! Once he was playing carrom and someone came and informed him that a Chrysler was up for sale. 'I don't want it,' he replied. 'Fine Salilda, but at least take a look.' 'I don't want it buddy, let me play.' 'Salilda, it's on instalment.' 'Okay, then keep it.' That was how he was. There was a story about him that used to do the rounds. If someone approached him with even an elephant, he would first refuse. But if the person could assure him with a 'pay when you can', he would probably ask the man to leave the animal tied outside. So, Salilda was always in need of money. Even though he did earn a lot, he was also quite the spendthrift.

Getting him to work was the most difficult task. Everything would happen, except the actual work. Say, we would remind him about a particular tune. 'We'll get to that,' he would say at once, 'I have just bought a car, let's all go to Powai. It'll be a trial run as well as a trip.' And the song would be tossed up in

the air as we would set out. This one time we were shooting for
Kabuliwalah. I had just come back to Bombay from filming title
shots in the alleys and roads of Calcutta (now Kolkata). Bimalda
informed me that two songs had been recorded and asked me
to listen to them. I heard the songs and told him that I was not
particularly fond of the bhajan. Bimalda answered with a 'Hmm'
and then asked me to finalize the tune of the song with Salilda.
But who was going to write it? Prem Dhawan had written the
other songs; how could I suddenly jump into the fray?

Deeply uncomfortable, I asked Salilda to reconsider and
confessed that it did not seem like the right thing to do. Salilda
assured me that it was Prem who had recommended my name
for the song since he was scheduled to go on a tour with IPTA.
Just so Bimalda would not stop him from going, Prem had
suggested I write the lyrics. Mollified, I agreed. It had to be set
to tune and when Bimalda asked me about it a few times, I had

to tell him that Salilda was not finding time to do it. As in, sort
of . . .

Rajen Tarafdar's film *Ganga* had released around that time
and I found myself swept away by the melody of the song *Amai
dubaili re* . . . (You have pulled me under . . .). A couple of days
later I visited Salilda at his house; he used to have a music room
there. I found him downstairs, playing table tennis. 'Salilda,
can't we use the tune of *Amai dubaili re* . . . in this song in
Kabuliwalah?' There was a frisson of annoyance from the other
side; I had interrupted his game with talk of work. 'Yes, yes,
that's fine. Go upstairs and get the notes from Kanu,' he replied
in a tone of irritation and dismissal. As directed, I went upstairs
to see Kanu Ghosh, Salilda's assistant. A little later, as we sat
working, we heard the sound of a station wagon approaching. It
was Bimalda's car. As soon as he heard the sound, Salilda rushed
to the piano upstairs like a wayward schoolboy and sat down
to play with such singular attention that one could mistake it
for a ritual that had been going on for ages. He knew exactly
when Bimalda came and stood at the door. But there he was,
a hermit deep in his meditation who had no idea what was
going on around him! He acknowledged Bimalda's presence in
a manner, as if he had just caught a glimpse of him. 'Bimalda, I
was wondering, what if we use the tune of *Amai dubaili re* . . .
in this song in *Kabuliwalah*?' He closed his eyes again and went
back to fiddling with the piano a few more times. Then he said,
'That's what I was thinking.' 'Sinking someone doesn't need
much effort, Salil, so just do your work.' Bimalda turned and
walked away in a huff as he finished. Hardly had the car gone

past the gates when Salilda sprang up from his seat, turned to me and spoke like a strict schoolmaster. 'Gulzar, you will sit with Kanu and finish the whole thing before you go.' It was as if I was the one who had been holding him back from work for so long, as if I was the one who had been trying to escape work. Barely were the words out past his lips when he was already downstairs and the table tennis was back on. What could I say? I was nothing but a spectator in this. The song was *Ganga aaye kahan se . . .* (O Ganga, where have you come from . . .).

This was Salil Chowdhury. The man and his music—like a torrent in the mountains, tumbling from a very high peak. As beautiful, as majestic, just as alluring and attractive.

Hemanta Mukhopadhyay

A very tall man, clad in a white dhoti and shirt, roaming around the city of Bombay in a Mercedes. There weren't many maverick Bengalis like this in the sixties. And I don't remember many rich Bengalis either. He was a singer, a composer and a film producer as well. This was Hemantada, Hemant Kumar, our Hemanta Mukhopadhyay.

I first met him the day he was set to record the song *Ganga aaye kaha se . . .* for the Hindi version of *Kabuliwalah*. As soon as he entered the recording room, he lit a cigarette. The mic in front of him, a smouldering cigarette in his hand. The fact that Hemantada was going to sing well was obviously a given. That was for certain. A constant. The recording got over. Surprised, I couldn't help blurting out what was in my mind. 'Hemantada, singers seldom smoke because they're afraid of hurting their vocal cords. And there you were puffing away while recording!' For Hemantada, anger, dejection, joy, all had a similar expression. Through a hint of a smirk he replied, 'Without it I don't get the perfect grain in my voice; it's never clear without it.'

There's one more surprising thing I can tell you. A man such as him, with such a deep baritone, he used to regularly take the snuff. Nevertheless, his voice remained the same. Undoubtedly, the gods had been extra partial with him. Hemantada had a unique way of taking snuff. The entire process of taking snuff was a long and elaborate one for him. He would first take out the little box of snuff from his pocket and tap it with his thumb. Then he would take a pinch of snuff between his thumb and index finger and, holding it thus, begin long conversations with people.

How long could a person keep their fingers like that? I would wonder. When was Hemantada finally going to inhale the snuff? Then, during a lull in the conversation, he would turn his face away for a moment and take a whiff. Then he would pull out the gathered hem of the dhoti tucked away in his pocket and wipe his hands, before tucking the gathered folds back into his pockets again. What amazing grace he possessed! He cut such a fine figure when he crossed his arms over his chest, in the style of Swami Vivekananda, and carried on conversations with people. His height, his unbent spine, modest image, stylish manner of singing and an idiosyncratic lifestyle—it all made for such a royal combination I have seldom seen otherwise.

Gradually, we became better acquainted. Often we would get together outside of studio work or recordings. Then, suddenly, Bimal Roy passed away, leaving us, his boys, to fend for ourselves like orphans. And Hemantada stepped onto the scene, with that gigantic heart of his that was so full of courage, generosity and love. He gave each of us work, showed us how to get work.

And he chose to help us of his own accord. Mukul Dutta was Bimal Roy's secretary. Perhaps Hemantada had already been aware of his interests in poetry. He told Mukulda to write Bengali lyrics and asked me to assist with the screenplays of his Hindi films besides writing the songs. Gradually, he helped others find work as well.

One day, as usual, we were all gathered in the music room of Hemantada's house in Khar. He was leaning on a bolster playing tunes on his harmonium, reclining a little. That was his style. And whenever he would finish a tune, he would sit up straight and sing the lines aloud before leaning back again. Suddenly he asked me, 'Gulzar, have you seen *Deep Jele Jai*?' 'Yes, I have, but a long time ago. I don't remember it very well.' 'So how about we make it in Hindi?' 'That would be great, Dada!' I was immediately reminded of Suchitra Sen's shots from the film. He said, 'Let's go,' and promptly got up to get ready. Just then, Beladi came into the room and asked, 'Where are you off to now?' 'Asit is here,' he replied, 'he's in a hotel in Juhu. We are going to see him.' So we went to meet Asit Sen and Hemantada asked him quite nonchalantly, 'Asit, what do you feel about making your *Deep Jele Jai* in Hindi?' Asitda replied in an even more indifferent and hurt tone, 'Who will make such films in Hindi, Dada?' 'I will, which is why we are here to see you.'

Asitda went all silent for a moment and then in the next ten minutes chaos descended as we launched into impassioned discussions regarding what would be the casting, where would be the location, what would be the budget and who was going to write the screenplay. On our way back, Hemantada instructed

his close aide Parimal, 'Then arrange for a trial show tomorrow, Parimal.' The latter replied coolly, 'Hemanta, for that we need to have the print brought over. That's not available in Bombay.' Only an immense amount of love, conviction and passion towards art can explain how someone can finalize an entire film project in ten minutes.

The shoot for *Khamoshi* began with a lot of fanfare with Waheeda Rahman playing the lead. One day we visited her house with Hemantada. That was the first time I was meeting Waheedaji in person. And what do I see! There she was, a dark girl! And she looked so fair when she appeared on screen! Though I lost heart a little, nonetheless the words of the song *Humne dekhi hai in aankhon ki mahekti khusboo . . .* (I have seen the fragrance in these eyes . . .) from *Khamoshi* began to simmer in my mind. I wrote the song and Hemantada composed an exquisite tune for it. And then dropped a bomb as he declared matter-of-factly, 'Lata will sing the song.' 'What are you saying, Hemantada! This is a boy singing to his beloved. This can't be sung by a girl for her paramour. It just can't be.' 'No, Gulzar, this will suit Lata well.' 'How can it? The song is about a man's emotions; how can it be sung by a woman?' We were unwilling, but Hemantada was adamant. Finally, we reached an agreement that the song would be sung over the radio by a woman. On the radio anyone could be singing anything. And quite surprisingly, till date no one has ever heard Lataji's song and complained about whether it was a man's song or a woman's! Such was the magic of Hemantada's music and his powers of observation. But the song caused me a lot of heartache. Critics began to whisper—was it a song or

a poem? How can fragrance be touched by hand? Lots of criticism of the young chap Gulzar who had written the song. But there was a poet hidden within Hemantada too. He told me, 'Gulzar, doesn't matter what anyone says. You must not change these lines.' Perhaps it's solely due to his encouragement that the word 'Gulzarish' exists!

Oh, I haven't told you this: it was Hemantada who made the down payment for my first house.

That was another incident. I was on the lookout for a house, something that Shyam, Hemantada's assistant, knew about. Around the same time composer Nachiketa Ghosh was looking to sell his North Bombay Society house. One day Shyam asked me, 'So, are you interested in that house?' 'Are you crazy?' I exclaimed, 'where do I have that kind of money?'

The day after in the music room Hemantada said to me, 'Gulzar, do you want to buy the house?' I looked at Shyam. 'I spoke to Dada,' Shyam said. 'Dada, how can I?' I repeated. 'It's a lot of money.' Immediately, Hemantada issued an order. 'You will go with Nachiketa Ghosh tomorrow and get all the paperwork done. I have settled the down payment.' I felt as if I was in a daze. Before I could utter a word, he added, 'Don't worry, I will deduct the money from you. Your job's permanent, you see.' The same hint of a smile. That was my first house. A respite from a life as a paying guest.

So, I had a small new house, a house that soon became a home via the glory of a bachelor's unaccustomed attempts at making tea, the growing piles of books everywhere and the signature element of bachelor Gulzar's new house—the endless addas

with friends. These addas included Hemantada, of course, even Tanuda, Tarun Majumdar, would join in from time to time. There were endless conversations, tea and Rabindra Sangeet for hours and hours.

On one such occasion, Hemantada was seated on a mat on the floor singing a Tagore song with full-throated ease, Tanuda was singing as well. All of a sudden Hemantada realized he could

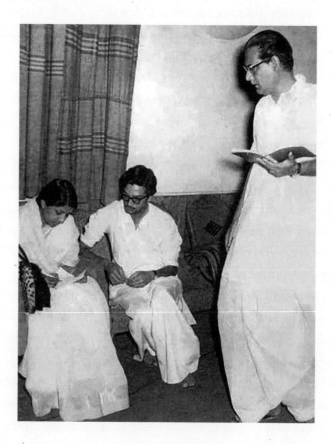

not remember a particular line of the song. Such was the bind that even Tanuda could not remember the words either. I was making tea. When I understood what the matter was, I took the copy of the *Gitabitan* from the bookshelf and looked up the song from the contents. Both were stunned and completely speechless. 'You can read Bangla so well!'

Throwing them a cocky look, I smirked and went back to finish the tea. I was silently preening myself; if only they knew how good I had gotten at reading as well as writing Bangla, it would have surely shocked them. Actually, neither of them knew the fact that by then I was regularly writing to and exchanging love letters with a Bengali girl (who would later become my wife).

It was weirdly addictive for me to hear Hemantada singing Rabindra Sangeet. When it happened, it seemed a lot; when it didn't, one felt like an addict going through withdrawal. Around that time I would often travel to Calcutta. During those visits I went to numerous programmes—they were called jalsas—with Hemantada. That was where I truly experienced the taste of Bengal's suburbs, towns and villages for the very first time.

Hemantada's fame at that time was soaring right next to the sun. In every jalsa he was the last one to be summoned. Adjacent to the huge tent or pavilion where the programme would be organized there would usually be a small tent for the artists. It would have wooden benches and chairs and perhaps some tea and biscuits at most. Just after a jalsa would begin, Hemantada would lie down on his back on one of the benches and keep singing songs, one after another—songs like *Amar ei*

poth chaoatei ananda . . . (My joy lies in watching the road . . .), *Jokhon bhanglo milan mela . . .* (When the curtains fell . . .), *Ami tomai joto suniyechilem gaan . . .* (The songs I sang to you . . .). Night after night I would find myself immersed in such divine moments; moments that were perhaps ordained just for me.

I don't think I have ever met a gentleman such as Hemantada. This one particular time I was working on the screenplay of one of his subsequent productions. The work had progressed a fair deal. One day I returned home to a note from him which read—'Gulzar, I will not be able to do this film anymore. I feel terrible about it, but quite honestly, it's not possible for me to take this project any further at this point.' This was possibly around the time when his film *Faraar* had flopped at the box office.

Can you imagine a charismatic and renowned singer–producer like him coming to the house of a junior lyricist–writer like me just to inform me about it? He could have just not said anything to me, or he could have just called. But that was Hemantada, a thoroughly emotional man. Perhaps he had thought I would feel bad if I heard the news over the telephone or from someone else, that I would feel insulted. So, he had come himself to inform me. So much empathy for a junior, not-famous, struggling artist! I had indeed felt very lucky.

Around the mid-seventies, times were changing. Bombay was changing even faster. Hemantada could sense it too. So, he made plans to move to Calcutta for good. This shifting process had been on for a few years already and gradually he wrapped up all his affairs and moved out of Bombay. I feel he had done the right thing. Bombay is very ruthless. They could not have

accorded an artist of Hemantada's calibre the respect he truly deserved. Rather, he would have faced disrespect and found himself in the depths of obscurity.

Bengal gave him the respect that was his due, gave him an artist's honour. That was his right. Hemantada could effortlessly contain within himself a sense of immensity but not everywhere can an immense artist like him be contained. Not everyone has a heart big enough for that.

Satyajit Ray

I had heard the news from Hrishikeshda. That 'he' wanted to meet me. At once I headed straight for the Sun & Sand Hotel. Enquiring at the reception, I was told that he was in the lawn. No sooner had I gone and stood in front of him than a deep baritone rang out—'Gulzar'. The z in my name perfectly enunciated, not at all like Bimalda's. 'Yes . . . that's . . .' I could barely finish my thought when he spoke again. 'Yes, I wanted to compliment you. Everyone had told me about you.' That was the first time I met Satyajit Ray.

That anyone could speak such excellent English, one had to hear it to believe it. Besides, that voice, that enunciation, even his body language while speaking English was like that of a true Englishman. And yet, when he would speak in Bengali, he would seem like any other familiar Bengali. The rest of the time he appeared unfamiliar, distant.

Around that time Manikda—I began using the name on hearing others call him Manikda—was planning to make *Goopy Gyne Bagha Byne* in Hindi. He wanted to talk to me about the script and the songs. The first thing I noticed was his biggest concern that the Bengali flavour of the film should not get lost in trying to make it in Hindi. I had loved it, that such a world-renowned filmmaker was unwilling to make any sort of adjustments regarding the uniqueness and melodiousness of his mother language. 'Have you watched the film?' he asked me. 'Yes, I have.' 'Okay, tell me how will you translate *sadha-sidha maatir manush* (plain and simple people of the soil)?' I blurted out whatever came to my mind, 'I don't think we need to change *sadha sidha* too much. And add *dehaati* to it.' This seemed to

reassure him enough to warrant two booms of the baritone—
'Good, good.'

The meeting got over. The next time when I travelled to
Calcutta, we had a detailed conversation regarding the script.
He asked his assistant to get the Bengali script and wrote down
the songs by hand for me. By then he was already famous across
the globe. Had he wanted, anyone would have written them
down for him. But perhaps he wanted to ensure there were no
mistakes. Seeing him was yet another lesson in how serious a
person could be about their work. His handwritten pages from
that day have remained with me as treasured heirlooms.

Goopy Gyne was never made in Hindi. My first chance
of working with him came to naught. But our relationship
remained. I would often visit New Theatres for work. Especially
to work with Tanuda, Tarun Majumdar. I would always drop
by Manikda's editing room on the first floor. On one such
occasion, I chanced upon Shashi Kapoor, Manikda and a few
others in conversation. I was standing a little apart from them,
and a sliver of the conversation has remained with me even after
so long. He was saying something on the lines of 'if we don't
have money to spend on it, we have to spend our brains'.

We got a second shot at working together. The daughter of
Karuna Bandyopadhyay, the latter had played the role of Apu's
mother Sarbajaya in *Pather Panchali*, wanted to make a Hindi
television series for Doordarshan based on Ray's Professor
Shanku series of stories. I was given the responsibility of writing
the scripts, with Manikda set to take a final call on them. With
that realization, I immersed myself wholeheartedly in the project.

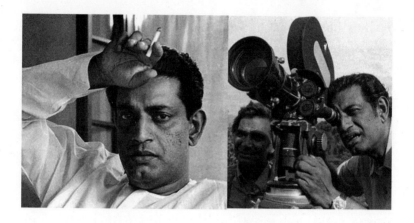

However, after a few weeks we were informed that the series was no longer going ahead. Manikda resolved to make it himself, not as animation like how they wanted it, but in live action. I joked that he had probably not liked my scripts at all, which was why he had rejected the idea. Some unit members told me perhaps my scripts had made him realize that the project could be something truly exceptional and so he was keeping the idea on hold for a while. Although the matter ended in jokes and laughter, I was nothing short of disheartened. For a second time I lost the opportunity to work with Manikda.

The third time it was I who approached him. I had heard he wanted to make *Shatranj Ke Khiladi*. On reaching his hotel to meet him, I got to know he had already checked out to catch a flight back to Calcutta. I took a taxi and chased after him to the airport. Back then there were not that many formalities and I could easily buy a ticket and walk into the airport. I managed to

catch hold of him. 'Manikda,' I said to him, 'I want to work on *Shatranj Ke Khiladi*. I want to write the script.' 'The thing is, I have already asked someone else to do it. They are looking into the costumes, the designs and various other aspects of the film as well. You know, one of those things . . . Gulzar.' What could I have done! For a long time my heart remained ensconced in a cloud of grief.

That's true even now. I never got to work with Manikda again, although we remained in touch. I am on good terms with his son Sandip as well. We ran into each other at a film festival once where he was a part of the jury. There was some special screening scheduled to take place. I told him, 'Sandip, I want to see the film. I will enter through the back via the projection room, won't bother anyone. May I?' 'You enter from the front and sit right in the front too. We have seen many films like this, even Baba used to watch many films like this.'

There was an incredible appeal in Satyajit Ray that encompassed his entire existence. An almost supernatural sense of cinema, a complete filmmaking talent, personality, fame, awareness, childishness, focus—it was a unique mix of all these things. Something that was truly out of the reach of ordinary people. Is even an entire lifetime enough to get over the regret of not being able to work with such a person?

Uttam Kumar

I have scarcely ever seen a more handsome man in the flesh. Uttam Kumar was so handsome even men could not afford to ignore his beauty. And just as beautiful were his manners.

I met Uttam Kumar properly during the making of the film *Kitaab*. I had seen *Nayak* before that, as well as Asit Sen's *Jiban Trishna*. A hero like none other, and after I met him, someone who seemed very close to the heart.

I had long nurtured a secret wish of making a film with Uttam Kumar. A secret wish, but a strong one nevertheless. I had never wished to make a film with Dilip Kumar, but I would often wonder how it would be if only I could have Uttam Kumar as the hero in one of my films.

When I thought of making *Kitaab*, I first thought of him. I called up his secretary. After a few pleasantries the call was passed to Uttam Kumar, and just the conversation itself impressed me like nothing else. He asked me to send him the script. Then, after a couple of seconds of silence, he said, 'Okay, I will do your film.' I was beside myself with joy. I have met very few true gentlemen like him. He had no hero-like tantrums. For me the

biggest gain was his agreeing to do my film without knowing almost anything about it.

During the shoot I found him to be extremely punctual. He would constantly rehearse his role. When he wished to chat he would do that too in his own inimitable style. But not for once did he have anything negative to say about anyone. Let me tell you about a particular incident. One day the topic of Asit Sen came up. I told him, 'Uttam Kumarji, you weren't shown even once in *Deep Jele Jai*. You were so good during that song, yet the camera only shot you from the back!' Quite calmly, with just a small smile, he replied, 'I didn't even act in that film. It was Asit Sen himself in that scene.' He was Bengal's biggest superstar—he could have just as easily gotten offended and asked me why I was speaking without getting my facts correct, that it was not him in that scene.

There was something remarkable in his manner. The person who used to appear like a god on screen, someone who could not be touched ever, the same person would seem so very different while chatting with someone or while fooling around. As if at any moment he would hug you and talk to you! I can confess that I was closer to Suchitra Sen, but I could never imagine hanging out with Mrs Sen or aimlessly chatting with her. Of course, we would joke, but there was always a distance. But with Uttam Kumarji, no such distance existed. What mysteries he possessed, perhaps only he knew.

It was this mystery that elevated him to a different class. His glamour, his acting, all of these were already enough to make people swoon. Besides, his off-screen charisma was no less.

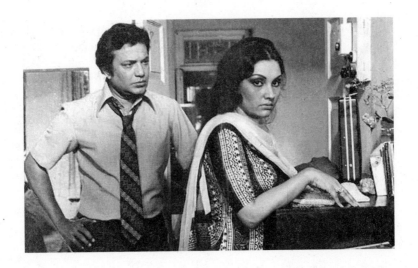

Such things can't be feigned. Without a genuine love for people or a genuine interest in their well-being, it's impossible to behave in such a fulsome manner with everyone.

Certainly, he had groomed and polished himself to acquire his unique style. A fan of his could perhaps watch his films numerous times to imitate his manner of speaking; they could imitate his smoking style and pretend to be smart, but there was no way they could carry themselves like him. And yet he was unbelievably effortless! He would sit and chat with everyone after pack-up, lounge about in his chair, laugh out loud, but the heroic touch in his attitude was ever-apparent. The way he used to glance at a person on being called, the gesture would appear rehearsed. But that would only last a second. Almost at once it would seem one had never seen a more spontaneous gesture.

It was truly sad that someone of his stature could not make a mark in the Hindi film industry in Bombay. I believe it was language that posed the primary barrier. He had some problem with his Hindi diction. My film did not need anything specific, so I hardly changed anything at all. But I did see his tremendous dedication fairly up close and so I can't help but feel regret. Had there been someone to guide him properly, teach him to enunciate his Hindi with care, show him where to stress the words correctly etc., he would have learnt it all like an attentive schoolboy. Had that been the case nothing could have stopped him from becoming a national star. He had a hero's looks and he could act—he had both these qualities. And the other thing that usually leads someone to their downfall, an unnecessary ego, he never had that problem.

It's truly unfortunate how soon he left us. He had been diagnosed with heart disease only a while before we began shooting for *Kitaab*, but seeing him on set there was no way anyone could tell. He appeared so fit. I remember going up to him and telling him, 'You look quite healthy.' 'Yes, I love staying healthy,' he had replied. 'I live healthy and I want to die healthy.'

It's undeniable that he was truly at the pinnacle of a fantastically healthy career, in every sense of the term, when he left us all of a sudden. Just like a Mahanayak, a matinee idol. Could he not have stayed among us a while longer? Could we not have demanded a few more reels from such a great actor?

Kishore Kumar

A mad genius. The term can mean anything. Someone mad who's a genius, or someone who's such a genius that they must be mad as well. And there's one name synonymous with being madly genius—Kishore Kumar. He was a friend; we worked together on a number of occasions as well. There are many ways in which one can describe what it was like to spend time with him—a difficult time but a time of revelry too, a time of being surprised but also of learning, a time of getting to know a person as well as misunderstanding them. A person evoking feelings of irritation while simultaneously also commanding respect, Kishoreda was multi-dimensional. One would be hard-pressed to believe that anyone could conduct their real life with such sense of humour if one had never met Kishoreda. There are many urban legends that exist about him, most of which are true. Simply because only someone like him could have conceived of or lived with such absurd truths. Once there was a producer who went to his house seeking a meeting. Kishoreda was not in the mood to talk to him at that time. He used to have this astounding cupboard that hid a secret staircase within. Kishoreda simply opened the

cupboard, stepped in and disappeared! Leaving the producer waiting for him outside the open doors of the contraption. If nothing else, this underscores the immense effort and planning required to live a life of absurdities.

We were shooting *Do Dooni Chaar* in which I was working as an assistant director. There was this particular scene of Kishoreda exiting a station. We decided to shoot the scene on the day Kishoreda was set to reach Khandala. That way, we could shoot two birds with one stone without having to arrange a separate shoot. We set up the camera and kept waiting for him but Kishoreda never turned up that day. An entire day's shoot cancelled, just like that. He had no sense of time. He would turn up on shoots when he wished, leave when he wanted. We would remain anxious about it, often quite irritated too. But whenever Kishoreda would be around, it was a time of laughter and sunshine. Many of you might be surprised to hear this but Kishoreda was all set to play the protagonist in *Anand*. Everything was final. A few days before the shoot Kishoreda was supposed to meet us to discuss his look in the film, his costumes etc. He turned up—completely bald. We were all shocked! On top of that, Kishoreda went around the office dancing and singing, 'What will you do now, Hrishi?' (the film's director, Hrishikesh Mukhopadhyay). Consequently, Rajesh Khanna was finalized for the role in a very short time. Perhaps Kishoreda never wanted to play the character. Nevertheless, I have never seen someone cutting off their nose to spite their face in such a manner. At the same time Kishoreda was the kind of person with whom you couldn't be angry or upset for too long. If I

did, the loss was all mine. It meant being deprived of an essence of world—the essence of Kishore. It had its own eminence, intoxication and feeling—all of it unique.

One of Kishoreda's most favourite things to do was to land his producers in trouble. It was never done to make the producer face some damage or loss. It was part fun, part justice. Once we were scheduled to record songs for a film called *Bharosa*. Rehearsals had been going on for a while and everyone was ready. Just before the final recording Kishoreda informed us that he wanted some tea. Abdul, his driver, was asked to fetch some tea. What followed was an endless wait; there was no sign of Abdul at all. Every time we tried coaxing Kishoreda, 'Let's go, Dada, let's get the recording done, Abdul will be here soon', he would counter with, 'Let Abdul come. I'll have tea and only then.' Soon everyone began to lose patience. We tried coaxing him a few more times but Kishoreda would not budge. Finally, when Abdul returned, Kishoreda immediately declared, 'Okay, let's record.' 'Why, don't you want tea?' we asked. Paying us no heed, he went to get the recording done. Actually, the tea was not really important to him. All he wanted was for the producer to spend money and get tea for all the musicians and the staff. That was what the whole charade had been for.

One day during a shoot Kishoreda revealed, 'Bimalda, yesterday a producer had come to see me. I told him I will sign his film but based on one condition. He had to come to my house wearing a kurta over a half-pant. He would have to be chewing a paan with red spit dribbling down his chin. At my house we would join two tables, he would stand on one and I on the other.

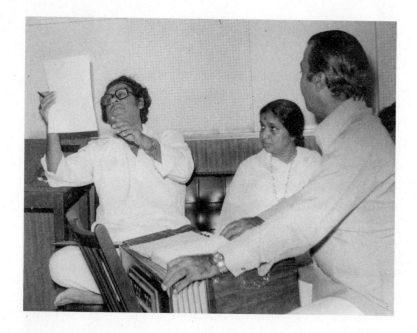

Then we would shake hands and sign the papers.' 'Why all this craziness, Kishore?' Bimalda had enquired. Bristling, Kishoreda had replied, 'Bimalda, the producer came to see me today dressed exactly like that. Now you tell me who's the crazy one, me or him?' I had no response to such logic.

This madness, this childlike naughty streak of his, none of it was fake though. He was exactly like that. Most of us who grow up and age as per the laws of nature are hesitant regarding such spontaneity and garrulousness. It is not surprising at all that those who do not possess the ability to think outside the box will regard Kishore Kumar with boundless wonder and a certain amount of envy. The amount of audacity and talent required

to live one's life on one's own terms—Kishoreda had them in spades. Not all of us have the capacity to accept such intensity. Nevertheless, to stay away from a genius such as Kishoreda? Who could have even thought of it!

Kishoreda's voice was indeed a divine gift. But the greater gift was his head, his intellect. No matter what life he lived—be it a colourful, crazy one or a life dedicated to music—he was always very conscious. Even in his madness he remained hundred percent aware. Lataji used to say the prospect of singing a duet with Kishoreda always filled her with dread. Back then duets were recorded together in the studio. Lataji and Kishoreda would start the recording together. When Lataji's part would come up, Kishoreda would go far away from the mic and begin teasing a musician here or tapping another on the head there. Lataji would confess that she was always nervous during recording. Would Kishoreda reach the mic on time for his lines? Would he be able to catch the cue on time? Would they have to do a retake? But every time Kishoreda would lay all speculation to rest and, having managed to make everyone's hearts skip a beat or two, pick up the cue with absolute perfection. He never missed. Those who used to be in the studio with him during such times would always relate how surprised they were that each time after so much fooling around, when Kishoreda would come and sing his lines, they would be in perfect tune and rhythm with no mistakes in the emotion or hardly any sign of exhaustion in his voice even after so much tomfoolery. His head was as clear as a picture, just as his voice. If this wasn't a sign of how partial the Almighty was towards him then what else was it?

Yet, we have come to know this person only as someone who was always amusing. We seldom spare any thoughts regarding his dedication, his choice of songs or even his acting in those songs. There used to be a huge portrait of K.L. Saigal in Kishoreda's room. Everyone knows he was a huge admirer of Saigal saab. Despite being such a jovial person, Kishoreda was particularly enamoured of Saigal saab's ability to communicate the feeling of pain through his songs. Kishoreda had internalized that exquisite pathos so distinctive of Saigal's songs and turned that inspiration into magic of his own. Hearing such songs in Kishoreda's voice made the soul glow dim, while not hearing them created such intense yearning. Despite this poignancy, Kishoreda has come to be known as a king of comedy. Except Sachin Dev Burman and Rahul, no one else sensed this pathos in him. Rahul made Kishoreda sing songs which were like wounds, longing for a soothing caress. In Kishoreda's own films or in the songs he composed, this cry of pain was a lot more evident. Perhaps he was more attracted to pain, or perhaps we can say it was a lot more exclusive. Which explains why he wished to indulge in this feeling of pain only in secret. He had carefully hidden away this side of him, a side that was inaccessible to others.

His heart was absolutely pure, untainted. No stain, no cut left any discernible mark in him, ever. That hardly means he never faced any hurt, because surely he did. But whatever it was, to him it was like water off a duck's back. Neither did he accept it, nor did he reject it. One evidence of how untarnished his soul was can be found in the number of instances when Kishoreda

ABSTRACT1

fell in love. Each time Kishoreda would find himself in love with all his heart and soul. Each love affair was pure while it lasted. And then when there was no love any more, Kishoreda would step aside. Can any of us claim to have shown such devotion or respect for love? After Ruma left, when Kishoreda fell in love with Madhubala, I have seen his ardour and devotion. I have heard many contrary things about it as well. However, I was there and I have seen how, as soon as the clock would strike six, Kishoreda would spring up and exclaim, 'There, the bell's rung. I must be off.' Madhubala was almost bedridden then and Kishoreda had to go visit her at a particular time. There was never any compromise there.

Let me relate to you another incident about how far things could go when Kishoreda decided that he was not going to compromise over something. He was new to the industry then. One day Ashoke Kumar had taken him to meet B.R. Chopra. Apparently, B.R. Chopra had taken one look at him and exclaimed, 'Oh, he's dark.' That's it. That had annoyed Kishoreda so much that for a number of years he did not sing for them or act in their films. For such a renowned banner! Whenever someone would ask, he would say, 'No, I won't sing. He said I was dark.' I don't know whether to consider this behaviour childish or not. However, at the very least, I can acknowledge the genuineness of his resolve. Later, he did get over his ire. The fact was that Kishoreda was reluctant to break out of his pure shell of childish innocence. Perhaps he used to believe fairy tales were real, magic carpets too. And he wished to live his life by those very truths. To ensure that the monotony of

life did not cast a pall over this sense of magic, he attempted to infuse fun into everything so that life remained sprightly like a pony and never succumbed to boredom.

It would be wrong to claim that Kishoreda did not comprehend reality. Rather, our reality was not the same as his. He wanted to cast aside the former and inhabit his own reality instead. That is what we, in our ignorance, will term as madness or cunning. And in response Kishoreda will sing, *Zindagi ek safar hai suhana* ... (Life is a wondrous journey ...).

Rahul Dev Burman

Anger, sorrow, dejection, hurt feelings, a sharp break in creativity—where could one expect to find Pancham during such times? The kitchen. Cooking up a new dish. Sometimes I saw it with my own eyes, at other times I got to taste it too. I am not a connoisseur of food, but I never turn my back on the culinary arts. Not that there was any way of doing so in the first place. Because it was Pancham rustling up such delights! Hotness in Pancham's food would often present itself very creatively and sensually. Sometimes it would be strong and raw, sometimes light but long-lasting. Something that would leave behind an after-burn, enough to turn the ears warm. It reflected whatever form creativity had chosen to make its presence felt in him that day. On the tiny roof over his garage, in numerous containers, Pancham used to grow a variety of chillies. Some from Burma, or Singapore, or native strains from Sri Lanka. It would not stop there. He would cross-breed different types and produce new kinds of chillies. Those who love his music not just by what they hear but by what reaches their soul will perhaps be able to appreciate this madness a little. When the chillies would

ripen and reach their prime, his joy would bubble over like that of a child. He would put different kinds of chillies in different dishes to produce innovations in taste. He would tell me things like, 'Eat that one, it will burn off the skin of your tongue,' or 'Have that, the slow burn will stay a long time,' or 'That one will burn a hole through your skull.' His skittish joy had to be seen to be believed.

I met Pancham at a film meeting for Bimal Roy; Sachin Dev Burman had come to discuss the music and Pancham had accompanied him with a dugga to provide a rhythm if required. After that, Pancham turned up at numerous other such film meetings where the two of us, like a pair of schoolboys, would sit and listen to the grown-ups talking and discussing. After a while Pancham would get up to go out to the balcony or to take a stroll. And immediately Sachinda would say, 'Yes, I know, he's gone off to smoke.' I too would get up to accompany him. Sometimes in the balcony he would tell me things like, 'I would have done that song this way.' I noticed our thoughts would often align. Our individual twisted ways of thinking began to seem fairly reasonable to each other. Consequently, a deep friendship gradually formed between us.

Pancham was set to turn composer with my film. We discussed a particular song. It was important that Pancham knew everything about the song; the beginning and the end, the sequence, what would be in the script, etc. I gave him a few lines as the mukhra to start off with. In the night, around midnight, Pancham turned up at my apartment, car horns blaring. 'Come down, I have a tune in my head.' Ever obedient, I promptly

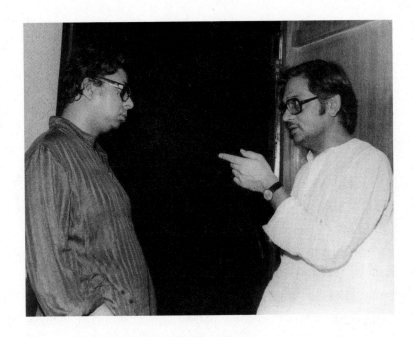

set out to accompany him in our night-time jaunt. He played a couple of recorded lines of music in the car's cassette player and then turned to me. 'Put words to this tune or I'll lose track of it.' 'Now?' I replied, 'In this car? How does that work?' 'You must,' he insisted. 'This is the song for your film.' I had to relent and write a few lines for the antara. Then a couple of lines more, then some more. Pancham too began to add lines of music to the tune he had originally recorded—the roads, lanes and by-lanes of nocturnal Bombay our only accompaniments through this process. The jugalbandi continued from midnight till four in the morning and we ended up finishing the song. That was

the first Gulzar film with music by Pancham—*Parichay*. The first song, *Musafir hoon yaaron* . . . (I am a wanderer . . .).

Describing Pancham as slightly crazy would be an apt way to understand him. And it was that identity that he always carried with him throughout every moment of his life, in every work, every song, every creation. One day I was on my way back home. I was sitting beside the driver, a little unmindful. Just before we were about to stop at a traffic light, I suddenly heard Pancham calling out my name—'Gullu! Gullu!' His car pulled up next to the car beside mine, he was driving it himself. Pancham being Pancham, he decided he just had to talk to me right at that instant. But how to make it possible? I noticed him asking the driver to roll down the windows facing him. Even before the unfortunate person could comply, Pancham further instructed him to roll down his other window as well. Completely flummoxed, the driver did as instructed and rolled down both sets of windows of his car, and Pancham launched into a conversation with me at the top of his voice through the car in between. The driver, caught in the middle, kept looking back and forth between us. It did not appear he had hitherto seen or imagined such an innovative mode of communication. As the signal turned green Pancham called out to me, 'Gullu, let's meet up ahead.' As in, I had to drive alongside him so he could keep chatting with me in the same manner.

That's how Pancham was. Otherwise, could anyone else have thought of inventing the breathy refrain *Aha-ha-ha* after two lines of the song *Duniya mein logon ko* . . . (In this world, people get fooled . . .), all under the influence of some very hot chilli!

That refrain itself became a defining factor of the song. Looking at Pancham, I understood that music had to be sought out in every grain of one's existence; sometimes it had to be dug out, grabbed at with both hands, sometimes even embraced like a tearful groan into a pillow.

Only then does Saraswati grace such people.

Tu ne sari mein uras liya chabiyan ghar ki . . . (You've ensnared my keys in your saree . . .). What are these lines? You call this poetry? How can song lines be so trite? Gullu, can't you write stuff properly? And you're asking me to put these lines to music?' —This was Pancham's reaction to the song *Ek hi khwab* . . . (Just this one dream . . .) that I had written for my film *Kinara*. He further added, 'I suggest you make a scene out of these lines and give me something else to work with.' I was never a confrontational person. I said to him, 'Pancham, I can always do that. But the thing is, when I work with you, we do it because we want to do something unconventional, isn't it? So . . .'. Pancham said nothing in response. He set about composing the tune. Some dialogue was added to the song as well to heighten the drama of the sequence. Once the song was ready Pancham turned to Bhupi, singer Bhupinder Singh, who used to play guitar with Pancham and was one of his most reliable artists. 'Bhupi, take the guitar, go to the recording room, listen to the song with headphones on and wherever you feel a note is required to complete the song, play those notes. I'm giving you a free hand.' Bhupi picked up Bhanuda's guitar—Bhanu Gupta, who worked with Pancham over a number of years and was almost a guru to Bhupi—and did as directed. With Bhupi's

notes the song seemed to find an extra dimension. Only in one place a screeching sound came into the track from the guitar. Pancham wanted to do one more take but I told him not to. Pancham threw me a challenge, 'Let's see how you manage this in the film.'

Pancham came for the screening once the film was done. In one scene of the song sequence, Hema Malini and Dharmendra are seen playing cards. Hema pulls out a joker and kisses it. I used the screeching sound of the guitar for that kiss. Pancham was elated. 'Gullu, wonderful!' His streak of perfectionism, wanting to infiltrate a particular word and subsume it within himself,

was like an addiction for him. When he wanted to understand a sound or a tune, he used to do it from within his very soul. Then again when the genius streak would show, results would be almost instantaneous.

Soda bottles too couldn't escape the onslaught of his ideas! We were working on the song *O majhi re . . .* from the film *Khusboo*. He asked me questions like, 'What sort of a village is the river flowing past? Are there other boats on the river?' 'You compose what you are thinking, I will ensure it's there,' I assured him. He always tried to capture the mood of the film. 'Don't villages have panchakkis? Can we use a sound like that?' Panchakkis were water mills in villages those days that used the force of flowing water from nearby rivers to drive the mills. How could a music composer think of a detail like that? Needless to say, I was quite surprised and I agreed. He immediately turned to Basuda, who used to play the double bass, and said, 'Basu, get two bottles of soda.' Very seriously Basu enquired, 'Soda? You want to start right now . . .' 'No, I'll use it to wash your face. Just go, get it!'

Two bottles of soda arrived from the canteen. Pancham emptied them in a bucket and filled them with water up to different levels. A 'kuk kuk' sound was produced with these two, which is there in the song.

Another fantastic song I must talk about, *Dhanno ki aankho mein hai raat ka soorma . . .* (The night lines the damsel's eyes with kohl . . .). I had given him only a simple brief about the song that it had to evoke the sound of a train. Once the tune was done he made me hear it. I gave him an ultimatum: he had

to sing the song in his inimitable style or I was not going to use it. He was a little reluctant at first but when the song was to be recorded, he told me, 'There'll be only one instrument playing in the song.' Pancham had just bought a new double-neck guitar. There was an odd tune coming out of it. 'That's all right but that tune doesn't sound anything like that of a train,' I pointed out. He suggested I introduce the tune early on in the film. So that every time it played in the background it would seem like a train departing for somewhere. As advised, I used the music during the title credits of the film and Pancham sang the song.

The song was filmed on a character-artist named Ram Mohan in the film. After the screening of the film Shammi Kapoor almost leapt at me in accusation. 'Why didn't you ask me to lip-sync to the song?' Very politely, I told him it was because the song was set in a train and it wasn't much of a character. Brushing my excuse aside, Shammiji replied in disapproval, 'Forget your train and character. Pancham has sung the song. I can lip-sync to his songs anywhere and under any circumstances.' Shammiji was that big a fan of his.

The more I am reminded of Pancham's genius, the more it brightens up my soul. And I can't help but reflect on what a huge personality I have worked with. However, while working together I never understood the magnitude of his genius. The fact is that when we are in a race we hardly have any sense of our speed; we can only make sense of it when we step out and observe from the sidelines. Can we guess the velocity of an aeroplane while travelling in it? Now that I observe Pancham from the outside, I can only marvel.

I was Pancham's repository of leftover tunes. 'You take this tune, Gullu. No one else will take it; they won't understand it.' All his strange experiments ended up with me. One day I was at home listening to a record he was playing. The fan was whirring overhead, both the sounds extremely droning. But he mixed the two to create an outlandish tune. 'Please give me a line,' he said to me, 'or I'll lose it.' I told him whatever came to my head at that point. Soon, we had a song. Immediately, Pancham was convinced that we had to use the song in my film. I was almost done shooting the film I was making at that time. I told him there was no place for the song anywhere. He was very hurt. 'Gulzar, if you don't take this song no one else will, no one else will get it. There are a lot of experiments with instruments in this one. See if you can do something, please.' I could never stand that look of heartbreak on Pancham's face. The song had to be placed with the opening credits of the film. The practice of having a song with the title credits rolling began with that film. This was *Chhoti si kahani se, barishon ke paani se* . . . (A tiny tale and the rains have filled this valley . . .) from *Ijaazat*.

There was this other hilarious incident, which involved a bit of a tiff as well. I had written another song for *Ijaazat* that I wanted Pancham to compose. He read the song and lost his temper. 'Gullu, tomorrow you'll ask me to set the morning newspaper to music!' My silence only served to stoke his ire further. He had figured out I was not going to change those lines under any circumstances. He composed the song *Mera kuch saamaan* . . . (I left some of my things with you . . .) while fuming with anger. The rest, as they say, is history.

Ashaji, Pancham and I made a cassette together—*Dil Padosi Hai*. I cannot even begin to describe the number of crazy experiments Pancham did for that. Numerous half-done tunes, experiments with strange musical instruments, some innovations—all these had been piling up over time. The cassette was to contain all of that, but try as we might, we were unable to get on with the work. One day Ashaji informed us with a fair hint of annoyance that if we were not interested in working on the album then she too was not going to think about it anymore. 'Gullu, let's go back to your place,' Pancham said to me, 'since Bob wants it, let's get this over with. I don't want to work on rubbish like this at my place.' Pancham's nickname for Ashaji was Bob. Work began on the album. One day Pancham came up with a 'pum . . . pum . . . pum' sound for one of the songs; the sound was kept intact when the song was recorded! He used a human sound like a tune. Ashaji came to me seeking help. 'Please tell him it's not sounding nice. If he hears I've said it, not only will he not listen but he will also get angry. At least he listens to you.' 'Fine, I will tell him you don't like it,' I told her, 'because I quite like it myself.' 'No, no,' Ashaji said immediately, 'that will make matters worse.'

In fact, one could never be sure at what point matters were going to go downhill when it came to Pancham. He was a guileless person in general, but he was so forthright that at times things would become prickly. Those days many directors or producers would get musical records from abroad and hand them to their music directors, demanding the latter compose songs and music based on particular tunes from the records.

One day Nasir Hussain, whose forthcoming film Pancham was going to compose music for, came by with a record which he handed to Pancham. Pointing out a specific song on the record, he requested the latter to compose a song along similar lines. Pancham, who was playing the harmonium in his inimitable style, replied, 'Nasir saab, I am a music director too! Give me an opportunity as well.' A hushed silence fell over the room immediately. It was impossible to predict which way Pancham's mood was going to swing. In the exact same situation he was capable of acting in a number of distinctly different ways.

His ability to constantly shift and change was reflected in his music as well. There is no one genre that can be picked to understand Pancham. Quite possible, he didn't have something like a trademark tune. Anything different would attract him. If there's such a thing as Pancham's gharana then perhaps it would comprise his experimental works.

Between Pancham and I there was a silent communication that existed. Is that what they call chemistry? Or was it an absolute understanding that stems from a sense of belonging? Can it be called belonging at all? Or was it that both of us had kept a part of our own selves in safe custody with the other, which ensured our views always took on similar hues. Perhaps that's what it was. It's what makes the most sense to me.

Pancham left us way too soon, didn't he? Of course, he used to always be in a hurry. He would ask for tea. The tea would arrive, boiling hot, but he would be in too much of a hurry to wait. He would pour water into the cup of tea to cool it and drink that while tinkering with a tune on the harmonium. No one knew why; not that he had anywhere to reach, nonetheless he would be in a tearing rush. That such a person would bid adieu to life before time is hardly that surprising. I have but one regret. That I was left behind, like some sort of an incomplete half. A large part of me departed with Pancham; the Gulzar that remains now is but half-complete.

Sanjeev Kumar

A Gujarati boy. A staunchly vegetarian family. The boy, a hard-core non-vegetarian. Of course, always outside the house. Non-vegetarian food was Hari's life. Hari, as in Sanjeev Kumar. Not only did he come over to my place often to partake of fish and meat, but his requests also often arrived via phone calls asking us to prepare non-vegetarian dishes which he would come and eat. And I was always ready to comply! Hari and I knew each other from way before we got involved in films. He used to do Gujarati theatre, was also a part of NTA, while I was a member of the IPTA. Both groups had a lot of common friends. Consequently, when both of us found ourselves leaning towards cinema, we also found the opportunity of working together. Before that Hari had appeared in a couple of small roles. But *Sangharsh* was his first big break. Who was to appear opposite him? Dilip Kumar. The first shot had the two of them playing chess. Hari wasn't excessively nervous or too overwhelmed. Rehearsals took place. Dilip saab came and made note of everything—the camera placement, how much time he had, etc. The first take got underway; Hari was in the shot. He took more time than he

was meant to, glanced at Dilip saab and then at the chess board, smirked and played his hand. He hadn't done even half of those things during the rehearsals. We were all surprised; the director was stunned. But the shot was so good that he forgot to yell 'Cut'. Even Dilip saab was taken aback. If anyone else had told me that they could be so thuggish in their very first shot with such a seasoned actor, I would have told them to stop lying.

The first time Hari worked in one of my films was for *Parichay*. He was cast in the role of Jayaji's father and he was very aggrieved. 'You've made me into a father in our very first film.' 'You are born old,' I had laughed, 'who am I to make you old? Don't you remember even Prithviraj Kapoor couldn't recognize you?' What had happened was that Hari was playing an old father in a theatrical adaptation of an Ibsen play, *All My Sons*, opposite renowned actress Leela Chitnis who was playing his wife. Leela's oldest son, who was at least ten years older than Hari, was cast as his son in the play. Prithviraj Kapoor had come for one of the shows. After the performance Prithvirajji had come to congratulate everyone and, while shaking Hari's hand, had said, 'All of you were very good but the person who was playing the old man was the best. Can you call him once?' Hari had been beside himself with joy on hearing this. He could barely manage to introduce himself as the same old man. Prithvirajji had been astonished and he had told Hari that day, 'You will go very far.'

Koshish was scheduled to release seven days after *Parichay*. In the latter, Hari was playing Jaya's father; in the former, her husband. He got very anxious. 'What will the audience think? Here I am playing someone's father and seven days later I'm

her husband! What will my image be? Please delay *Koshish* by a couple of weeks.' My producer Mr N.C. Sippy had the perfect response at that time. 'If the actor is superb, the audience watches the character and not the actor. If the actor isn't good, only then does the audience notice them, not the character. I believe Hari is a great actor, ask him not to worry.' That's what happened as well when Hari won the National Award for Best Actor for *Koshish*.

With Hari everything was good—he was a wonderful person, a great actor, had an incomparable sense of humour—all except one thing. He had little or no regard for the concept of punctuality. We were shooting *Namkeen* and, as usual, Hari was turning up late every day. He just couldn't wake up early in the morning, even though the three fabulous actresses Waheeda Rahman, Sharmila Tagore and Shabana Azmi would get their make-up done on time in the morning and keep waiting for him for almost two hours every day. I could never reprimand someone when they turned up late on set. If I found anyone late, I would write on the back of a reflector, 'Impunctuality is Immorality. Be punctual', and fit the reflector right in front of the entry to the set. One day the three ladies complained, 'You put a reflector in front of us if any of us is late. Why don't you do the same with Hari?' 'See, after trying to make him understand for years I am very tired now,' I told them, 'I have given up. If you three can teach him a lesson, then go ahead. I'm with you.' The three ladies decided that when Hari turned up on set, none of them were going to talk to him. They were going to feign anger, no more joking around and having fun either.

Hari came on set and immediately sensed something off in the air. For a while he remained a little perplexed. Whenever he used to be late, the moment he stepped on set Hari would say, 'Let's get the master shot done first.' In a master shot a lot of the scene can be finished in one go, it saves time. That day too there was a master shot scheduled. We began canning the shot. Now when I remember the incident it all seems like a dream to me. The shot got over, the three actresses who had thus far been angry with Hari went up and hugged him. Everyone was elated. The shot had gone so well, so amazing Hari had been in it.

When you watched him act, it didn't seem like he was acting at all. His amazing sense of timing made it appear as if he had invested in it a piece of his soul.

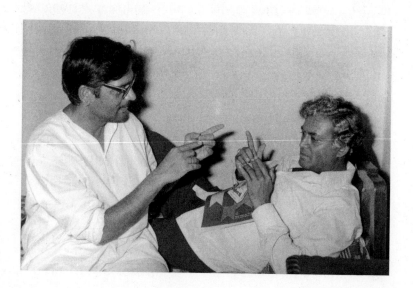

I find myself awash in a crowd of memories of Haribhai, of his sense of humour and his sensitiveness. Amidst all of this, having fun was what came instinctively to him. He never got married; it was a huge cause of regret for his mother. Whenever I saw her, she would implore me to talk to Hari and make him see reason, make him understand the importance of marriage. There was this one particular evening gathering at his house. This was in 1975–76. A lot of informative programmes used to be telecast on black-and-white television those days. People used to watch everything, from the weekly television dramas, the film song programmes, to the agricultural news. That evening some such heavy discussion was in progress, something to do with kidney transplants. At some point during the discussion someone raised the point that only blood relations of the recipient could donate a kidney or someone with whom their blood group was a match. Even a wife could not donate a kidney to her husband. The moment this last argument was uttered, Hari loudly commented, 'Then? What use would marriage be? Even my wife cannot donate a kidney to me? Then what's the use?' Then he turned to me and continued, 'You tell me, am I wrong? If she cannot even give me a kidney then why should I get married?' As if that was the precise reason he had been waiting for all along. No other argument against marriage could have been that potent!

On the one hand, Hari was a very generous person, on the other, he was a miser and very careful with money. He had once told me, 'I will drop by your house whenever I want to. When I do, I will want a drink. That's my demand. Don't tell me then

that you don't have a drink for me. If you want, I can buy a bottle and leave it here as well.' When Hari used to act in my films he would recommend many of his old theatre colleagues who were not doing well. Throughout his life Hari silently helped numerous destitute artistes. At the same time there was this famous writer whom Hari would take a dig at from time to time. 'Hey there, I had lent you forty bucks to buy a typewriter, remember? You still haven't paid me back. Those forty rupees I gave you were the biggest contributions to your success.'

Hari never took life seriously. If he had, then perhaps he would not have been able to treat his illness with such a cavalier attitude. Had that attitude been right or wrong I cannot say, but his passing left behind a huge vacuum in my life.

Hari had congenital heart disease. Once, after much cajoling, we did manage to convince him to undergo a bypass surgery. The operation happened abroad. He resumed his regular work on returning.

One day on my way back home around midnight, I was passing by his house and saw him downstairs chatting with friends. I stopped the car and went up to him. 'Aren't you supposed to be asleep by now? And here you are chatting away?' He pulled me aside and told me seriously, 'See, there's been a problem. The vein they needed during the bypass surgery, they took that vein from my legs. So now my heart's constantly kicking. How do I go to sleep?' This was how he used to joke about his heart-related condition.

Hari passed away. I didn't get the news immediately. My daughter Meghna came and told me, 'I think Sanjeev Uncle's

passed away. I saw a lot of people in front of his house on my way back from school.' It seemed the world had come crashing down on my head. I rushed to his house at once. His body was kept for two days, for relatives and others. Throughout those forty-eight hours Shatru remained by Hari's side, Shatrughan Sinha. He didn't budge for even an instant. It's so astonishing that when someone is alive, how much of life do we manage to live with that person? Perhaps we don't think it to be important.

I never kept track of how many films Hari did with me. Once, I had turned up a little late at a party. The host had asked me why I was so late and I told them I had been at a shoot and it took time for pack-up. Hari was there. He had immediately said, 'Shoot? No, that's not possible. How would you make films without me? No, no, he's speaking rubbish.'

Quite truthfully, Hari used to lend a separate spark of life to my films. *Mausam*, *Aandhi* or *Namkeen*, through all of this and more, he was a huge component of my life. When I started making films again after his passing, all the time the only thing I could hear in my head were his words, 'How would you make a film without me? Rubbish!' After his passing, my films always served to remind me of this. 'What sort of a person was I that I could make films even after he was no more?'

Hrishikesh Mukherjee

He was ostensibly just an editor. But if you don't know about him then you would be hard-pressed to believe that in those days, at a time when the likes of Dev Anand, Guru Dutt, Dilip Kumar were ruling the roost, an editor in the Bombay film industry could be a star as well. We were nurtured under the same guru, but at different times. I, as an assistant director to Bimalda, and he, as an editor. He later turned to direction and made films like *Namak Haram*, *Guddi*, *Golmaal*, *Khoobsurat*, *Musafir*, *Chupke Chupke* among many others. And in the process, Hrishikesh Mukherjee became a darling of the nation.

He was so tall. And just as lofty were his thoughts and opinions. Middle-class lives, low budgets and remarkable films—this was Hrishida's calling card. I worked with him on numerous occasions, sometimes as a screenwriter, a dialogue writer or even as an assistant. We learnt a lot, argued a lot and made a lot of films together as well as on our own.

For Hrishida, the definition of small budget itself was synonymous with his own self. For instance, he would build a set for a drawing room in his own house; later, he would have

it all removed and replaced with new furniture for perhaps an office scene. Then again the office furniture would go and be replaced by a bed, etc. to pass it off as a bedroom. Hrishida's brother-in-law was an art director and he had to go through this rigmarole time and time again. Suddenly, Hrishida would tell him things like, 'Quickly paint these two walls.' Because otherwise the same walls could not be passed off as another house in another scene. This way the same room could be used to portray different rooms or even different houses. How to shrink one's budget from small to smaller was something one had to learn from Hrishida.

We were shooting a song for *Khoobsurat*. There was a small theatre sequence within the song. Hrishida instructed his art director to think of ways in which it could be done without spending too much. 'I can't book an entire studio because of a two-minute song sequence. It'll be too expensive.' The art director wracked his brains and came up with the suggestion of shooting the sequence on the roof. Hrishida looked as if someone had handed him the moon. 'That's a brilliant idea. With the water tank, the pipes and the open space, the whole roof has a character of its own.' That's what was done. I was summoned to make alterations to the scene and dialogue. A stage was built with two large paper cut-outs and cloth. In the film when the song appears, the setting seems to heighten the warmth of the familial vibes on display.

It was while working with him that I began to appreciate why Hrishida was considered a star editor. I will scarcely be able to stop if I begin recounting the kind of brilliant things he came

up with from time to time. Once we were shooting a song for *Namak Haram*, probably a duet featuring Rajesh Khanna and Amitabh Bachchan. Rajesh Khanna was a superstar around that time. He had not reached the set yet, but Amitabh was already there. Hrishida asked us to start the shoot. What was the man up to! How could we shoot without Rajesh Khanna! 'I am telling you, start the shoot,' Hrishida snapped at us. 'The camera will first move from Amitabh's left to his right; when we shoot Rajesh on the same line, the camera can move from right to left. Plus a couple of joint shots should do it.' That's exactly what happened too, and what a splendid shot it was. None of us could ever have conceived of utilizing a crisis to our advantage in such a manner.

People often accuse others of deliberately chopping their roles or dialogues during the edit. Hrishida used to cut a film while shooting it. He would edit the film in his head while directing it, that's how sharp his focus was. Once we were shooting another film with Rajesh Khanna. The shot was rolling and as it got over Hrishida yelled 'Cut' and almost immediately said, 'Ready the next shot.' Rajesh went up to him. 'We must take the shot once more, Dada. I forgot to speak the last lines of the dialogue.' 'I know that,' Hrishida replied, 'don't worry about it. It will overlap with the next scene.' Such was the keenness of his mind. Back then, it was only Hrishida who could have shown the guts to move on to a new shot in such a manner and not let a superstar like Rajesh Khanna finish his lines. He had an incredible rapport with everyone in the industry. There were hardly any leading actors or actresses who he did not work with,

such as the likes of Dilip Kumar, Raj Kapoor, Dev Anand, Guru Dutt, Nutan, Waheeda Rahman, among others.

Everything else was fine, but if his addiction to chess ever got to him, then it would be impossible to find Hrishida. Often on set he would sit down over a game of chess with Rahi Saab, Rahi Masoom Raza, which meant he would lose sight of everything else. Once it so happened that he instructed me, 'Gullu, you take the shot.' He was too preoccupied with his king to concentrate on anything else. As a compliant assistant I did as I was told and set about canning the shot. I fixed the lights and came up to him to inform him. 'Dada, I'm fixing the lights this side.' 'Hmm,' came a reply. The next time, 'I'm setting up the trolley here. It's fine, right?' This was met with yet another 'Hmm'. When I went up to him for the third time—'After this dialogue, I'll pan the camera from the left'—he exploded. 'Gullu, do I have to pay you separately now, only then will you take the shot?' I sensed in the air immediately that the king must be in dire straits. Hrishida was facing an impossible choice—should he save his king or concentrate on the shot? I believe Hrishida made the former choice, because it was I who took the shot eventually.

In fact, his addiction to chess literally drove me out of mind on one particular occasion. What happened was that Hrishida and his scriptwriter Dr Rahi Masoom Raza were in the middle of a bout of chess. Meanwhile, we managed to finish the day's shoot and it was very late by the time we were done. As we sat discussing the next day's shoot, we realized that the scenes we were supposed to shoot the day after had not even been written. Because the screenwriter had been busy playing his rook and

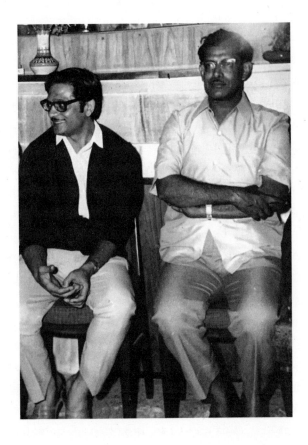

the director had been planning a checkmate. On nights such as these the person who got called in was Gullu, yours truly. Riding high atop his confidence Hrishida would say, 'Chotu, go have Gullu write this scene.' Chotuda, as in D.N. Mukherjee, Hrishida's younger brother, would dutifully come to my house and I would stay up through the night working on the scenes for the next day's shoot. At times Chotuda would simply turn

up at dawn; I remember yawning and writing scenes, morning breath and all.

We had umpteen tussles, arguments, differences of opinion and whatnot over scripts; some of them I won, some he did. It was the process which was truly educational. I remember this one incident during the shoot of *Guddi*. The scenes were being written. *Guddi* was a personal favourite of mine because it was based on one of my short stories. While the shoot was happening, we got news that a large set of another film had been gutted in a fire. Hrishida asked me to shoot a scene which would involve a photographer approaching Dharmendra for a photograph, only for the latter to turn it down and ask what would be the point of photographing him when there were numerous workers and spot boys affected by the fire whose plight required more urgent attention. 'It's going to get too melodramatic, Hrishida,' I told him. 'Do as I say,' he snapped at me instead. The scene was written and shot, but throughout, Chotuda and I kept telling him to edit out the sequence because it did not fit with the rest of the film. Hrishida refused to listen to us. On the day of the film's release, we were in the theatre, standing in an aisle at the back to gauge the audience response. Hrishida was in front of us. The moment that particular scene came on, the audience broke into thunderous applause. Hrishida turned around to glare at Chotuda and me. Very sheepishly, we left the spot.

However, I must admit that Hrishida also gave us a lot of creative freedom. I was writing the dialogues for *Anand*. In the sequence where Anand goes to the hospital for the first time, I felt that given the nature of his character it seemed too trite for

him to just turn up at the hospital without any fuss. Anand was at death's door, but he was still determined to not give in. In order to foreground this aspect, I had introduced small suggestive lines of dialogue and characters at various points in the screenplay. While writing this particular scene, I gave Anand a one-liner where he teases a man with a 'Hey, fatso . . .' on his way in. I knew the line was going to get cut because shooting it meant hiring an artist for the scene—it was all too much trouble. But when I landed up at the shoot, I found Hrishida shooting with a portly artist who he had hired just to highlight the flavour of the character.

And yet, it was an error on someone's part due to which my name was left out of the title card of *Anand*. After the film released, it was my sister who informed me that my name was missing from the credits, but I assumed she had made a mistake. Then I heard the same thing from others. By then I had gotten the news that in the two–three days since the film's release, the dialogues were already a big hit. Justifiably, I got upset, but I could not say anything to Hrishida myself. Someone else went on my behalf to inform him. All the prints were recalled and my name was added.

There was another incident just like this. The film *Abhiman* was jointly produced by Amitabh's and Jaya's secretaries. No one involved took any remuneration—neither Amitabh and Jaya nor Hrishida. When the two had first approached him for the film, Hrishida had told them that he was going to Pune for ten days and on his return if the script was ready then he would do it. So, Chotuda and I had spent sleepless days and nights in Khandala and prepared the script.

This very same Hrishida had a childlike side to him as well. All of a sudden he would do things that would make it hard to believe that seriously an adult was behind the acts. Imagine Bimalda calling him for some work—'Hrishiiii . . .' —Hrishida, the king of excuses, would suddenly begin to walk with a limp. It was true that Hrishida had gout, but this sudden limp was nothing but an excuse. There he was, Hrishida, limping towards Bimalda, when suddenly Sudhenduda, Sudhendu Roy, would call out—'What's all this, Hrishi? You have gout on your left foot. Why are you limping on your right?' Hrishida would immediately correct himself and begin limping on his left foot.

Once we were in London working on a film. It was biting cold; the shoot was on. Hrishida would get ready before everyone else every day. And he would be reeking of some fragrance. So I asked him what the matter was, how was he managing to get ready so quickly? 'Because, unlike the rest of you, I don't take a shower every day. A healthy dusting of talcum powder is enough. You guys are mad. Who takes a shower every day in this cold? It will reduce your lifespan!'

Hrishida loved dogs. He would treat his pet dogs like they were human beings. Once someone went to meet him for the very first time. After a while Hrishida called out for someone to get some tea. At once the guest said hesitantly, 'No, it's okay, I don't want tea.' Hrishida quietly replied, 'My dog is addicted to tea. He drinks tea every day at this time.' Can such a man's sense of humour and mischief be contained in words that do justice to his creativity?

Pandit Ravi Shankar

The swirly, zany tee-shirt and jeans-clad man who entered my room, much to my shocked surprise, was Pandit Ravi Shankar. Yes, the very same man with whose music we grew up culturally. I will not get into clichés of how great Ravi Shankar was or how he put India on the global map, etc. Just allow me a moment of pride. Pandit Ravi Shankar and Ustad Ali Akbar Khan had performed a jugalbandi at Bhartiya Vidya Bhavan in Bombay on the occasion of Ustad Allauddin Khan saab's birthday. I had bought tickets for and had attended that historic concert which was later released as a record that created a sensation worldwide. I had listened to them play all night long.

I knew him, though not too personally, from the time of the IPTA. He had composed music for the film *Dharti Ke Laal* and all the members of the IPTA had worked with him on it. From there, cut to New York. My first time in America, only to meet Pandit Ravi Shankar. At this point we must segue into a bit of a flashback—to the time when prep was on for the shoot of *Meera*. The sets were being put up and a song was to be recorded, when suddenly Lataji declared she was not going to

sing in the film. I was a little surprised and dejected. I asked her why she did not wish to sing. 'I have done a non-film album with Hridaynath Mangeshkar recently, I don't want to sing anything else at this point.' I accepted her reasons. On the other hand, Laxmikant–Pyarelal, the composers for the film, soon began to make excuses and delay the recording. One fine morning I found out they were not willing to score the film anymore because Lataji was no longer involved. Okay, that was fine as well. But by then the sets were up, with shooting set to start in a couple of days. Being my friend, Pancham knew the whole thing was about to drop on him any moment. He called me one day. 'Gullu, you're my friend. But Lata didi is not singing. If Asha sings to my score then it will only stoke controversy. This might cause trouble on the family front.' Completely in a dilemma, I approached Premji, the producer, and explained everything to him. 'No problem, we will make sets again if needed. But *Meera* must happen,' he said to me.

We racked our brains and came up with a name, someone who was not from the industry and beyond all controversies— Pandit Ravi Shankar. But who was going to approach him? We had Hemen Chowdhury working in production at that time and he knew Kamalaji. Kamala, a tambura player, was a close acquaintance of Panditji and had accompanied him on many concerts, besides also coordinating all logistics for Panditji's concerts in India. Hemenda got in touch with Kamalaji and the latter informed us that Ravi Shankar was in New York and we could get in touch with him if we wished to. Hemenda made the call. 'I will do it only if I like the script,' Panditji told us.

His words boosted my confidence and I informed Premji that I wished to speak to Panditji directly.

I called him over the telephone and was greeted by an affable voice at the other end. 'If I like the script only then will I do it. You can send me your script.' 'What if I go myself and read the script to you,' I asked him. 'You want to come to New York?' 'Yes Sir, I want to.' A moment of silence at his end and then he said, 'Fine, come. I will make arrangements for your stay.' Premji advised, 'Don't go alone. Take Hemenda with you. You don't know him.' That was my first visit to the United States. We reached and went straight to our hotel. In the evening the doorbell of the hotel room rang and ushered in my moment of shock and surprise at the sight of the middle-aged gentleman clad in swirly tee and jeans.

The fact that he would drop by to meet us in person had been beyond my imagination. We spoke and it was decided we would visit him the day after with the script. Once we met and the situation had been explained, he asked, 'And yes, what's this controversy with Lataji? I don't wish to get into any hassles.' He told us he wished to talk to Lataji. She was in Washington on a musical tour at that time and I got in touch with her. 'Fine, if he calls, I will definitely speak to him,' she told me. Mukesh was accompanying her in the tour as well and I spoke to him too. And it was for the last time, for it was during this tour that Mukesh passed away.

I was all nerves. How to tell Panditji that Lataji wanted him to call her? So I mustered all my courage, puffed my chest and, softening my voice as much as I could, told him hesitantly.

'Oh all right,' he said, 'I will call Lataji.' With increased reach and scope, perhaps nothing remains out of reach. We decided he was going to make a few sample compositions in the meantime. He had a number of concerts lined up at various places soon and he was going to compose some scores for me in between concerts, with the rest scheduled to be completed in September. 'Dada, I want to record the songs in September,' I told him fearfully. 'How's that possible!' he exclaimed, 'even if I do finish my compositions, won't we have to sit with them?' 'What if

I go to these concerts with you and you keep composing in between?' He looked at me for a moment, a soft smile lighting up his face, which turned into a full-blown guffaw. What he said in response essentially amounted to 'Boy, you're way too adamant.' I accompanied Panditji to London and we managed to do some work there before I had to return. Then, again I accompanied him to Amsterdam. And this time I was star-struck. The concert was organized inside a church in Amsterdam, dusk to dawn. A number of renowned artists were part of the line-up. Panditji took the stage a little before midnight and I finally learnt what it takes to create such a night. From dark black to dark blue to some darker unfathomable shade of night, it was entrancing. The spell eventually broke when I observed the first rays of sunlight filtering through the high panels near the roof of the chapel. Strains of Raag Bhairavi were wafting from the sitar, Panditji welcoming the dawn like he had ushered in the night. As if the fragrance of the new dawn was wafting in with his musical notes.

We returned to Bombay from Amsterdam and Panditji returned to New York. 'There won't be any trouble,' he told me, 'you will be able to record songs in September itself.' We marshalled our wits and set to work again.

However, one concern refused to fade away. Lataji was not singing, nor was Ashaji, so who was going to give voice to Meera's ditties set to Panditji's tunes? It was Ravi dada himself who came up with the solution. 'If Vani Jayram were to sing, would you have any objections to it?' What objections? I had just been handed the moon! 'Of course not,' I told him, 'and her

first Hindi song was written by me. *Bole re papihara . . .* (The cuckoo sings . . .) for the film *Guddi*. She was astounding.' 'Yes, actually I want someone who's classically trained,' Ravi dada elaborated, 'because I need a mature voice that can foreground the classical tunes and its entrancing effects in these new renditions of Meera's bhajans. I think Vani will be able to do it.'

I was as excited as a child. Something momentous was about to happen. Meera's fascinating lure had me in complete thrall. Panditji arrived in September; by then the rest of the songs were ready. The recordings began, the music gradually starting to spin a magical web. Our shifts started at nine in the morning and would go on till nine at night. The first few days went by like a dream—the songs were being recorded, and we were completely enthralled by the melody. Panditji was doing everything he was supposed to—the songs, the recording, rehearsals, correcting mistakes, retakes—everything was perfect. On the fourth day, once we were done recording, Panditji asked, 'Tomorrow can we start recording at two in the afternoon?' 'Of course,' I replied, not bothering to ask why. I simply assumed he had some reason for which he wanted to shift the timings.

The next day Ravi dada turned up at the studio at 2 p.m. sharp, bringing in his wake a rush of laughter, a wave of joy and lots of commotion. It seemed the whole studio was suddenly alight. A while later he called me and explained. 'Do you know what had happened? For the past few days I didn't touch my sitar. If I don't get to do my riyaz, it feels as if there's something incomplete running within me. Today I played continuously from four in the morning till twelve noon and made up for

some of that deficit. Now I feel a lot more energized. Come, let's embrace our Giridhar Gopal again.'

I was stunned. That was the day I realized what 'sadhana', true commitment, entails. This is something to experience, not something that can be explained. Words are scarcely enough to encapsulate this feeling.

We finished recording, the record was released, my dream project *Meera* finally got made. Panditji and I remained in touch after that. We did meet from time to time, occasionally as they say. One such occasion was in Agra. His daughter, Anoushka, was a little girl at the time, and that was also the first time I met his wife Sukanya. However, a strange memory, uncomfortable or perhaps funny—no matter how I put it, made the meeting memorable. After chatting for a while, Sukanya suddenly asked me a question. 'I look a bit like Rakheeji, don't I?' I was stumped. What could be a reasonable response to such a question was beyond my reckoning. No matter how much I juggled with words, language and sentences, I realized that I was yet to master the art of coming up with a big, smart reply. 'The two of you are beautiful in very different ways,' I faltered instead, 'it's too difficult for me to judge.'

However, I did notice a ghost of a naughty smile flitting across Panditji's lips. I did not try and decode it further.

Samaresh Basu

Samareshda and I met because of *amrit*, the elixir of the gods. He went on a quest for it; I was enriched by reading all about it. His narrative on the Kumbha Mela, *Amrita Kumbher Sandhane* (In Search of the Elixir), used to be serialized in the magazine *Desh*. Bimalda was a dedicated reader of each instalment. He wanted to adapt it into a film, which was going to be his greatest work, his magnum opus. But it was not meant to be. From the screenplay to shooting scenes at the actual Kumbha Mela, a lot of the work was done. And on the day of the ritual holy bath, Bimalda left us to journey for the great beyond.

I was inextricably connected to the book. Which is why, some invisible force ended up tying me to Samareshda as well. There was a lot of pain regarding the unfinished and aborted film adaptation of *Amrita Kumbher* . . .; the pain of Bimalda's passing was fresh too, but getting acquainted with Samareshda managed to ease some of the hurt. It was Debu Sen who first introduced me to him. Debu Sen was the leader of the Bengali clan I used to be a part of. He was the one who instilled in me a whole load of Bengaliness.

A head of curly hair and a winsome smile, these were Samareshda's trademarks. I was so captivated by him, it took nearly ten minutes for the spell to break. After that we were nothing but ardent friends. I have scarcely come across a more simple man. It only served to enrich my life and friendship. Whenever I would travel to Calcutta, we would get together and have a gala time. Whatever he had written new, whatever he was about to write and whatever new ideas were gnawing at him— we would sit and discuss it all.

One of his published short stories was 'Akal Basanta' (Untimely Spring). To put it simply, it was stupendous. I could not resist; I wanted to make it into a film. However, while writing the script, I realized that some changes had to be made. I asked Samareshda if I could make the alterations. 'Of course,' he replied generously, 'bioscopes always need such changes.' But the film took more time than expected. Before that I adapted another one of Samareshda's short stories, 'Pathik' (The Traveller), and made the film *Kitaab*. The story had been first published in the film journal *Ultorath*. It was for *Kitaab* that I first met Uttam Kumar.

Not that I gave up on the first story. 'Akal Basanta' would keep tugging at my senses from time to time. This was *Namkeen*, one of the most favourite films of my life.

Samareshda's stories exert this strange pull that drives me on. There was this one story called 'Aadaab', which, as soon as I read, I decided I had to make it into a film. While writing the screenplay, I realized it was too short to be a film, but I was not one to give up. Around that time, I was making a television serial called *Kirdaar* for Doordarshan. I chose the story to be a part of the series. At the end of the story a Hindu and a Muslim bid farewell to each other and say Khuda Haafiz, instead of Aadaab. I renamed the story as 'Khuda Haafiz' and included it in the series. Later, I also wrote a play based on the screenplay of the television serial.

My rapport with Samareshda gradually transformed into a deep camaraderie and kinship. Travelling to Calcutta meant a mood of reckless holidaying. While I was limited in my recklessness, Samareshda was truly uncontrolled.

It was this attitude towards life that gave him such an eccentric flair for writing. I have heard about the struggles he had to go through in the beginning. I cannot help but believe that had he not possessed such a boundless pull towards writing, Bengali literature would surely have missed out on such a brilliant and prolific writer.

Since people like Samareshda choose to live such different lives—the life of nomads, so to speak—they have been able to draw out life from the oddest of places, be it a marsh, beneath the arches of a feudal mansion or a truck driver's den. Had he continued being a nomad for some more time, Bengali literature would have only been enriched by it.

Basu Bhattacharya

It was Basu who first read out Subhash Mukhopadhyay's poetry to me. I used to live on rent in a place called Chaar Bangla at that time. That was where, thanks to Bimalda's assistant Debu Sen, I met Basu Bhattacharya. Back then, we used to have a raucous Bengali adda. I was so immersed in it that I even began to don a dhoti–kurta from time to time. I always love Bengali food. The only thing missing back then was a Bengali girlfriend. Understandably, it didn't take long for Basu and me to grow closer. It was poetry that sparked this friendship between us. Basu would come and recite different kinds of poems. Besides, he was a poet himself—a fact very few people are privy to. Many of Basu's poems were published in various Bengali magazines and journals. So inspired was I that I tried my hands at translating Subhash Mukhopadhyay's poetry.

This was the time when Basu was already working with Bimalda; I was yet to begin. Later, by the time I began my career with Bimalda, Basu had already gotten busy with making his own films. Basu's first film was *Uski Kahaani* (Their Story), a small-budget feature. All his subsequent films were

small-budget ventures as well, made by our entire group of friends. None of us ever got paid for any of this work, a fact which Basu used to consider his birthright. His logic was that those who were working on his film, if they were already earning from elsewhere, then there was no point in paying them further. In fact, while making the film *Avishkar* (The Discovery), Basu had told Rajesh Khanna, 'Listen, what you need is a good film, a good character, you don't need money. You're already a superstar.' Quite possibly, Rajesh had agreed to this. In case of small-budget films, this is a logic that I subscribed to as well. We friends—we made so many films like this for our own sake. Perhaps the audience didn't accept it every time, but it gave us a lot of fulfilment nevertheless.

From the very beginning Basu was inclined towards a different kind of cinema. His films used to travel to festivals. Once we were in Moscow and it was very cold. He handed me his overcoat and said, 'You take this, hand me your shawl.' The very next day I told Basu, 'I can't wear such a heavy overcoat. It seems like I'm carrying you on my shoulders.' I returned the overcoat but never got the shawl back. In fact, Basu never felt he had to return the shawl to me. That's the kind of friends we were.

One morning I got a telephone call from him. 'Come over. You'll have lunch with me. I'm cooking.' Greedy at the prospect of Bengali food, I immediately agreed. Basu was an excellent cook. In fact, I don't remember if Rinki, Basu's wife, ever cooked for us. I reached their place only to discover that a new trouble awaited me. Basu was in the middle of prep for his film

Griha Pravesh (Housewarming). He informed me I would have to play a small role during the song *Logon ke ghar mein rehta hoon* . . . (I live in people's homes . . .) and in another scene too. I refused outright. 'Then I won't give you anything to eat today,' he threatened. I had to relent purely out of greed and pressure exerted by Sanjeev, who was another foodie. Consequently, I made an appearance in the song as a character sitting and sipping on tea. There was another scene as well, but that didn't turn out too well at dubbing.

And our friendship? One morning he turned up at my place in a huge rush—I used to live in Juhu then—holding a voucher.

'Sign this. I want to pay you for writing songs for my film.' I was quite flabbergasted. This was not how it was supposed to be. That too he was holding a blank voucher. 'This is blank,' I told him. 'Yes, I need this for my income tax. And listen, lend me two hundred bucks.' Then he turned and left.

Another one of Basu's strengths, or flaws, depending on what one calls it, was that he was quite the chatterbox. He would drop by my house and if there was someone already there to see me, Basu would begin chatting with them even without knowing the person. He would enquire what problems they were facing or if there were issues plaguing their locality and try to find solutions to such problems. At times he would come back the next day and ask me about the person. 'Could they figure a way out of their problem? If not, I can take them to the chief minister, if required.' Basu loved to rush to people's aid and perhaps because he talked so much he could very easily become close to people. Although, I must admit that only on one occasion did this garrulous nature of his really annoy me. It was the day Bimalda passed away. For the first time in my life I was facing devastation, I was completely at a loss. And Basu kept on saying a thousand things about Bimalda's death, even when we were at the crematorium. I felt very bad about it.

When Basu was in the hospital, then I felt terrible too, quite terrible. It was not as if he was gravely ill. *Aastha* had just released, there was talk of holding a premier of the film in America. 'You go on my behalf,' he told me, 'I will never be able to go anywhere again.' Perhaps he had spoken to the doctor and figured something out. I was never the one to be very stubborn

when it came to friends. But that day I mulishly told him, 'Basu, I'm staying with you. I'm not going to America. It's more important that I be by your side. If that means the premier of your film in America will not go smoothly, then so be it. Find someone else.'

Now when I think about it, I feel I had made the right decision that day. Only a few days after our conversation Basu left us; his effusive nature went with him. A hungry silence seemed to descend upon me. Even now whenever my surroundings become unbearably quiet, I feel how nice it would have been if I could call Basu over again.

Ritwik Ghatak

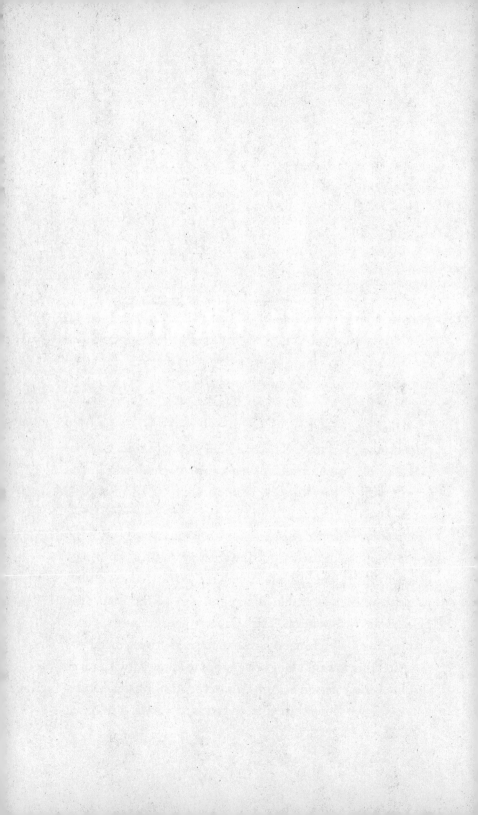

The moment you saw him, it seemed as if a Greek master was standing in front of you. Tall, dishevelled hair, unbuttoned khadi jacket over a kurta, a bag slung over the shoulder and a pair of incandescent eyes—as if any moment a supernatural tale was set to begin.

I first met Ritwikda, Ritwik Ghatak, through Bimalda. His elder brother used to be Bimalda's head of production. One day Bimalda called me and said, 'Listen to his story and write it, take notes as well. We have to develop it into a script.' So, Ritwikda and I got to work, the first of many such instances when we got together, although none of it ever materialized into a film. It was only later I learnt that Bimalda never turned away empty-handed any Bengali in need. But helping Ritwikda without any exchange of work would have been an insult to him and also hurtful, something Bimalda was well aware of. Which was how I had become a witness to this incredible exchange of love and respect between them.

After this, it wasn't long before I got to know Ritwikda as an absolutely dear person at Abhida's, actor Abhi Bhattacharya's, house. Every evening there used to be raucous adda at his place.

Those days the Bengalis of Bombay were guaranteed to be found in one of two places. The first was a place of work—Bimal Roy Productions. This was because Bimalda was an affluent producer who would nourish and sustain people, me included. I was a converted Bengali as it was. The second was Abhida's place, where everyone would gather to relax. Being a new Bengali, wherever I used to find my kin, I would usually insert myself there. It was at Abhida's house that I first read the story *Jatugriha*, in Bengali.

Each day in those gatherings we used to make a new film, discuss the cast and the budget and who was going to write

the script—everything. Only for it all to be scrapped the very next day in favour of a new film, a new and different kind of cinema. Whenever the discussion turned to music, almost all of us would say in unison, 'Oh that, Salilda will do that, who else?' 'What! Salil will not compose the music,' Ritwikda would explain about his dearest friend, 'rather he'll be passed out drunk somewhere.' We would all look at each other, wondering how Ritwikda could make such a comment. Then everyone would burst into laughter and begin teasing Ritwikda, who would probably be drunk by then.

I had already been introduced to his films. Till this date I cannot forget the scene where Supriya's slipper tears in *Meghe Dhaka Tara*, or the scene with Anilda singing a bandish under that huge tree. The very act of choosing such a tree as the foreground was a master's touch. Its massiveness, its regality takes the scene to an altogether different stature. When I first met Ritwikda I was reminded of that tree. Such dishevelled royalty.

The spell somewhat broke after watching *Subarnarekha*. A couple of scenes were so melodramatic that I didn't like it. Perhaps there were many things pertaining to Ritwikda that I did not like. For instance, I did not like how he conducted himself during his tenure as Dean of the Pune Film Institute. I believe a certain amount of distance between the teacher and the students should have been maintained there. Not everyone can take so much bohemianism in their stride. If your admirers follow you blindly, it might not always be beneficial for them. It should have been handled responsibly. Somewhere, the whole

thing lacked discipline. Whatever he had to contribute, had he channelled himself properly it would have only enriched the institute further.

However, I have also reflected upon if Ritwikda would at all have been who he was had he been disciplined and 'proper' in the traditional sense. He would have been a different person. His life itself was melodramatic, that was the only way he knew how to live and create art. That was his gharana, his way of life, what was reflected in his cinema. Perhaps his predilection towards breaking rules was a tad genetic as well. I used to know both his brothers well and I noticed the same streak of eccentricity in both of them too.

The artistic landscape is made up of diversity of talents. There will always be those who are nomads, radiant with talent and transient like comets. We must learn to accept such people on their own terms.

Many years later I met Ritwikda near the Khar station in Bombay. He would always put up at a lodge near the station. The same old uncombed wild hair, unshaven, khadi jacket, the same regal air, except for physical ravages visible on him, lacking only just a little lustre. As soon as we met, I bent down and touched his feet. 'What have you done? That you are so famous now?' he asked me with a light, playful slap on my cheek. Only he could have said such a thing. He had known the young chap in question for a long time and that too very closely. No matter how light the slap, even playful swipes with such big hands required guts to digest. I believe I had the guts! A small token of love from a Greek master.

Pandit
Bhimsen Joshi

I will not claim that I know a lot about classical music. However, it was fairly early on that I came to the realization that the genre possesses an intoxication of its own. Pandit Ravi Shankar's sitar, Amjad Ali's sarod or Bhimsen Joshi's songs—all of them made me heady. There was just one thing that I never did particularly like—the hand or facial gestures that were trademarks of practitioners of vocal classical music. In fact, I am not an admirer of tennis star Nadal precisely because of his habit of pursing his face constantly. But . . . but one person had forced me to make an exception to this. Pandit Bhimsen Joshi. When Panditji used to sing it would seem as if he had caught hold of the tune by the neck and was dragging it down, scolding the tune till it settled itself down in his voice, like chastising an errant boy. The speciality of his voice, what we call timbre, was exquisite. And the energy with which he used to sing was always captivating for me. I used to always have Bhimsen Joshi cassettes in my car. However, if questions arise about the singular characteristics in particular facets of his voice, I would scarcely be able to make sensible responses. All I can say is that hearing him sing made

one feel as if they had just emerged after a dip in the frigid waters of a serene pool.

A friend of mine had his son's birthday on 10 October. Every year on that day Panditji would visit their house, and we got the chance to immerse ourselves in his music. Once, on his birthday, Vinod Khanna decided to forego a glitzy party and instead chose to invite Panditji to perform for the day. I turned up to listen. Vinod insisted I sit somewhere in the front. I settled down, huddling as much as I could. An artist of such calibre and I was supposed to be right in front while he performed! Director Raj Khosla was in the row ahead of me. As soon as the performance began, he started nodding his head, occasionally letting out a 'Wah! Wah!' as well. Suddenly, Panditji stopped mid-song and said to him, 'Sir, you seem to be applauding even before I've made a shot over the boundary. I'd rather you move a few rows back. And you, you come up front.' Calling me to come and sit closer made me even more nervous. Afraid that I was going to nod at probably the wrong places during his performance, I sat scared stiff throughout the whole thing.

And then look at my good fortune, for it was I who was commissioned by the Films Division to make a documentary on him. Originally from Pune, Bhimsen Joshi's childhood was unfortunately not a very happy one. He lost his mother at an early age and grew up with a stepmother. On his way to and from school he used to pass by a record shop playing Ustad Abdul Karim Khan's songs. Young Bhimsen would listen to the music, spellbound and would try and sing on his own. He was eleven. One day, presumably because his mother had put

only a small amount of ghee on his roti, he had a huge argument and ran away from home. When he had related the incident to me, I had enquired in surprise, 'She put less ghee on your roti and more on your stepbrother's, and that's why you ran away from home?' Casually brushing it aside he had replied, 'All I was looking for was an excuse to do just that. Back then all I wanted to do was learn music. The only way I could do so was if I ran away from home.'

He had already heard about the great classical music scene in Gwalior, and that Hafiz Ali Khan, Amjad Ali Khan's father, was a celebrated musician. Without a ticket, he boarded a train for Gwalior. But how could the ticket checker in the train understand the significance of his earnestness? Besides, he had no money to pay the fine either. So, he was made to disembark the train and sent to jail. It was like this—spending a few days in jail here, a few days on the road there, taking a train without a ticket again, again being roughed up by the ticket checker—that in about two months he managed to land up in Gwalior. He had jokingly admitted to me once, 'In this two-month journey, if I ever managed to catch hold of someone who understood music, I would almost tie them down and make them listen to Ustad Karim Khan. Think about my guts! Some checkers would listen to me sing, then box my ears and throw me behind bars.'

In Gwalior he sang in front of Ustad Hafiz Ali Khan. The latter was stunned by the vast possibilities in classical music in a voice so young and got him an admission into the Scindia School in Gwalior. He did undergo training in school but didn't seem to be learning much. It was in riyaz—something he did on

his own—that he found refuge. Nevertheless, he could not stop school altogether because going to school meant one free meal a day. And apparently, at night he would lurk around Khan saab's house at dinner time and manage to find a meal there. Khan saab too had a keen eye for true gems, otherwise he would not have insisted on personally teaching Raga Darbari to such a young boy.

This training lasted two years. During this stint Panditji came to know of a renowned guru named Vishmadev Chattopadhyay

in Calcutta, who was considered a god of music. So, he fled to Calcutta next. But how to get trained by him? Panditji found out that Vishmadev Chattopadhyay used to regularly visit actor Pahadi Sanyal to train him in music. So, Bhimsen Joshi sought and found employment in Pahadi Sanyal's household. There he used to cook, pack food for Pahadida in tiffin carriers and take them to movie sets, and continued his musical training in secret.

After staying at Pahadida's for about two years, Bhimsen Joshi travelled to Jalandhar. Back then a gala music conference called the Harballav Sangeet Sanmelan used to be held there once a year. Renowned classical musicians from across the country would attend it. Panditji found his next teacher in a visually impaired classical musician, and spent two more years there. The Good Samaritan also arranged for two square meals a day for him from a nearby hotel.

It was at the music conference that Bhimsen Joshi heard Sawai Gandharva perform. The latter was originally from Dharwad, near Pune. It was under Sawai Gandharva that Joshi found permanent tutelage. He moved in under his guru's roof and continued learning. From drawing up his baths, taking care of his meals to cleaning the house, Panditji used to do it all. Once he told me, 'I keep getting reminded of someone. Initially, when I used to go with a pitcher to fetch water for Guruji's bath, there was a woman who used to watch me. After a while whenever I would go to fetch water, the woman would stop me on my way and give me a glass of milk to drink. Wasn't it strange?'

Once his training was over, Panditji moved to Bombay. Soon he sang for the All India Radio, his records were brought

out by HMV. The rest, as they say, is history, bits of which we know as well.

Panditji was such a huge personality, but he was also very childlike. Once, in order to explain to me just how old he was, he said to me, 'Listen, I have heard Begum Akhtar sing standing and perform.' Utterly surprised, when I asked what that meant, he explained further. 'At first people get a chance to stand and sing. Once you progress from that level, only then do you get to sit comfortably with a harmonium to perform. When I used to know her, she used to stand and sing.'

After becoming famous, he was once in Calcutta for a concert. Pahadi Sanyal arrived and took a seat in the front row. After his performance was over Panditji approached Sanyal and said, 'I am that Joshi of yours.' Sanyal was so shocked at the revelation that he could barely react. The boy who used to fetch his tiffin was now such a renowned singer! Panditji never forgot the expression that came over Pahadi Sanyal's face that day.

Panditji used to love driving. Back in those days he owned a Mercedes that he used to often take out and drive to Mangalore, Bangalore and many other places. Often he would drive himself to his own concerts. One morning, I remember reaching his house early to find him savouring some parathas with pickles for breakfast. Dumbstruck, I had said to him, 'You're having pickles! Aren't singers not supposed to have all this?' 'Having done riyaz for hours and hours for so many years my throat has now become like dry wood. No matter what you do, nothing will happen to it,' he had replied.

Panditji used to love drinking. At one point this had reached such a state that he needed to be kept under watch. Once I had accompanied Panditji and his wife to a concert in Bombay. Before the programme was to begin Panditji said he needed to use the bathroom. I waited for him to go ahead. All of a sudden his wife came up to me in a huff and said, 'Don't let him go to the bathroom.' I was quite flummoxed. How could I stop someone from going to the bathroom of all things? 'How is that possible?' 'Oh, you don't know,' she said, 'there must be a bottle hidden in the bathroom somewhere. He will surely come back drunk.' I couldn't stop him that day. Neither did I try and find out later if Panditji had indeed gotten drunk. Instead, I promptly went to find my seat and settle down.

There are stranger incidents than this. The doctors had asked him not to drink but there was no way to restrain Panditji. So, his wife and two sons decided that they were going to keep him under house arrest. Food and medicines would be brought to his room, and since the bathroom was attached, it would be no trouble for him. It was decided that the door would be barred from outside. A couple of days went by, and the stance of the family members gradually began to thaw. Panditji was made to promise that he was not going to touch alcohol anymore. As soon as the door was unlocked, Panditji emerged from therein with a small bundle and walked out of the house to the temple nearby. He placed the bundle in front of the idol of the goddess, opened it and spoke to Ma Durga. 'Ma, my wife is extremely cruel, she does not deserve anything. I hereby offer all her jewellery at your feet.' He finished and marched off.

When his family members followed him and reached the temple, they found out he had gathered all his wife's jewellery that had been locked up in the cupboard in the room, tied it all up in a bundle and donated the whole lot to the temple as revenge on her for not letting him drink. Somehow, his family managed to retrieve everything in the end.

Such a person, who rose to such levels with his music, could also become a peevish child, an infant Bholenath if you will, in regular life. Is it possible to become such an artist without such contrasts?

Mahasweta Devi

In 1968, a Dilip Kumar–Vyjayanthimala starrer film became very popular. *Sunghursh*. For me the experience was akin to discovering a pot of gold. I had written the dialogues for the film. Before that Abrar Alvi had already prepared a screenplay with dialogues from the original story. But for some reason he withdrew from the film midway and I was employed in his stead.

My first task was to read the original story and write dialogues based on it. Abrar Alvi saab had already done a portion of the work, but when I took over, it seemed to me as if the story was a treasure trove. I was a long-time fan of the writer, since a number of her stories had already been translated into Hindi. But this particular piece had me spellbound. The original story was 'Layli Asmaner Ayna', which was adapted into *Sunghursh*. That was the first time I became closely acquainted with Mahasweta Devi. So close, in fact, that I wrote a poem inspired by one of her short stories, even though we did not meet in person until much later.

After this I wrote the screenplay and dialogues for the film *Rudaali*. When I was first offered the film, two versions of the

screenplay had already been developed. I started off by reading the original story and trying to draw the screenplay as close to the original as I could, to ensure the film foregrounded the author's vision.

It was many years later that I finally got to meet Mahasweta Devi face-to-face in Delhi, at a meeting of the Sahitya Akademi. The topic of the meeting, coincidentally, was literature and cinema. There I clearly explained how I felt any work of translation ought to be reviewed by the original author once, if possible; otherwise it often happens that the essence of the original work gets lost. This was especially true in case of adaptations. I had adapted Mahasweta Devi's 'Layli Asmaner Ayna' and 'Rudaali' into screenplays, and in both cases tried to stay faithful to the original to the best of my abilities. It often did happen that we had to merge multiple characters into one or give one's lines to another. All writers need to make such decisions when required. Purchasing the 'rights' to something does not give one the right to change everything.

Didi, Mahasweta Devi, told me, 'I agreed to part with the rights of "Layli Asman . . ." for a different reason. I am a huge fan of Dilip Kumar. When the producer informed me Dilip Kumar was going to be in the film, I did not even stop to think before agreeing. My hero was going to play a character I wrote, what more could I possibly ask for?' All of us burst out laughing on hearing this. Despite being such a celebrated figure in Indian literature and the recipient of so many awards, she too harboured such desires. We were accustomed to assuming that such people were not starstruck like us.

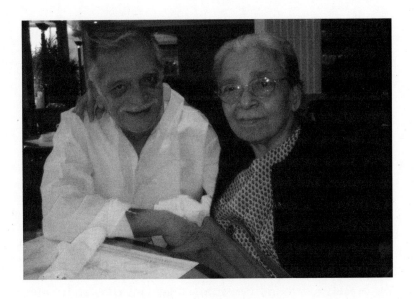

It was soon after this that I was blessed with one of the biggest achievements of my life. As we were exiting the meeting, Didi said to me, 'Gulzar, I have read all the stories you have written for your daughter. In fact, I have given them to numerous kids as gifts. Such beautiful writing, such a stunning ability to understand the minds of children—very few people are so gifted. And you are one such person.' I was elated. The fact that she knew who I was, that she was aware of my work outside the everyday fare of films, overwhelmed me. I could hardly utter a word in response. That day onwards *she* became my Dilip Kumar.

Such incredible energy! She used to work all the time. Or kept thinking about different things to do all the time.

She wrote, took part in protests, and worked towards the betterment of the Adivasis. She sold the rights to her stories to film-makers in order to be able to work for the welfare of the Adivasis. I had never come across a woman of such robustness of mind and heart. She was truly a heroine unlike any other.

The next time we met was at the Frankfurt Book Fair. In 2006, India was the 'First Country', a guest of honour or focus of interest, and Mahasweta Devi was the chief guest. There she delivered a speech, talking about her country, its heritage, its literature, culture and so on, and I had scarcely heard such a touching speech. It made my eyes well up. After the event I didn't see her again that night. Next morning when I went down for breakfast, I found her sitting alone at a table and eating. I walked up to Didi, got down on my knees and placed my head on her lap. She fondly kissed me on my forehead. For me, it was the biggest gift possible from my Dilip Kumar.

Suchitra Sen

Back in the day when I used to be a regular at the tea shanties of New Theatres, on certain days a particular wind would begin to blow. Things would go into overdrive, everyone would get a little anxious. 'Mrs Sen is coming', 'Mrs Sen is coming'. Something would whip people into putting their best foot forward. Such was her grace, her reign. By then, I too had caught a couple of glimpses of her and come away amazed. Of course, I had already seen her on screen. Going toe-to-toe with Dilip Kumar in *Devdas*, only she could have pulled it off. Only she possessed such a luminous screen presence. I watched *Deep Jele Jai* and remained sitting in the theatre absolutely dumbfounded. And nowhere was Suchitra Sen a more matured actress than she was in *Saat Paake Bandha*. Yes, later her acting did find a new dimension with *Aandhi*, but in both the aforementioned films, the glamourous heroine's deglamourized look, her sedate presence and her astounding performance served to show her in an entirely different light.

Once, producer Sohanlal decided he wanted to make a film with Suchitra Sen. Accordingly, I prepared a script. In fact, I

spent a fair amount of time over it. All said and done, Suchitra Sen was going to be in it. We went to Calcutta, to Mrs Sen's house in Ballygunge Place, and read her the script. As soon as we were done she began suggesting changes, to alter this part of the script to that, make one character do something else, etc. I was quite put off and declared that I had spent a lot of effort and thought on the script. There was no way I was going to change things. I also told her I didn't believe she was that big a writer who could suggest changes anywhere or dictate actions of other characters as soon as she had heard the script. I told Sohanlalji to have someone else take over the script, that I was not going to write it. Or have Mrs Sen do it herself. Having made the declaration, I walked out and the film was shelved as a result. That was my first interaction with Suchitra Sen. The incident left Sohanlalji deeply dejected. 'I had even given the signing amount, you spoiled it all,' he would lament. I had young blood coursing through my veins then. I had very little patience unless someone had a reasonable argument regarding my writing.

A few years later, I was summoned by J. Om Prakash to talk about directing a film—a thriller, based on a story by Sachin Bhowmick, starring Mrs Sen. Besides, Sanjeev Kumar was very keen on acting with her, it was a long-standing desire of his. So, we sat with the story one day. I heard the whole thing and then asked them if they were so keen on making a film with Suchitra Sen then why had they chosen this thriller? If you wanted to work with an actress of her calibre, then the story too had to be equally impressive. Sanjeev was of the same mind and, much to our surprise, even the writer Sachin Bhowmick himself

suggested that if we were to work with Suchitra Sen then we had to create something specifically for her. The producer tasked me to think of a story. I wrote *Aandhi* as a short story for the very same purpose. When I read it to them it seemed as if that was the story everyone had been waiting for.

In the middle of all this something else happened. Renowned writer Kamleshwarji spoke to me regarding his wish that he and I work on a script based on a story he was going to write, and that I direct the subsequent film. Mallikarjun Rao was going to be the producer of the project, so accordingly we travelled to Madras to meet with him. Unfortunately, the producers did not like Kamleshwarji's story and turned it down. Just then my assistant Bhushan Banmali brought A.J. Cronin's story 'The Judas Tree' to our attention, which was later adapted into *Mausam*. Mallikarjun Rao fell in love with the story and asked me to work on a script based on it. Suffice to say I was quite embarrassed at first. It was Kamleshwarji who had taken me to Mr Rao. He was such a renowned writer and we were friends as well, but his story had been turned down in favour of another one. Nevertheless, Kamleshwarji, Bhushan Banmali and I decided to travel to Mahabalipuram and work on the script together. I asked Kamleshwarji to write the second story, while I resolved to finish the script for *Aandhi*.

But our ensuing days in Mahabalipuram passed in voluble conversations, aided by prawns and alcohol, with one script butting heads with another from time to time. Consequently, in the end we had nothing at hand to speak of. I was growing restless about writing a story for Suchitra Sen. Exasperated, I went off

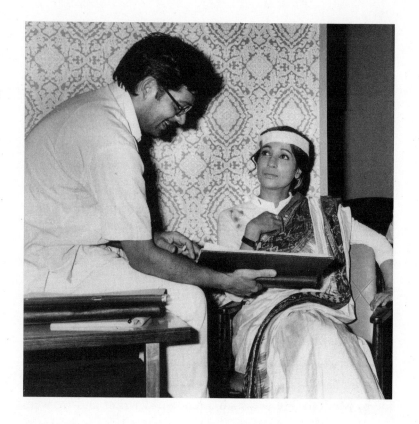

to Delhi on my own. In a room in Akbar Hotel I finally finished the script of *Aandhi*. The hotel employee who used to fetch me food, tea etc. and run all my errands was a boy named J.K. For his sake, in the film Sanjeev's character was named J.K. as well. In that room in Akbar Hotel began the journey of Suchitra Sen's *Aandhi*, Sanjeev Kumar's *Aandhi*, R.D. Burman's *Aandhi*. Later, we also decided that Kamleshwarji would novelize both the stories.

With the finished script I travelled to Calcutta along with producer J. Om Prakash. As soon as we met Mrs Sen at her residence on Ballygunge Circular Road, she glanced at me and said, 'No discussion, no questions. I will not ask any questions, I will accept whatever you say.' I was quite mortified, of course. She clearly remembered our first meeting.

She agreed to do the film as soon as she heard the screenplay. With a small smile, I told her, 'You will not be able to edit any characters in this film or make any modifications as such. Because as it is there are so few characters in the script, plus there's only one female character, you.' Mrs Sen was quite surprised, because just like the others, she too had not realized that there indeed was only one female character in the film. In fact, even after watching the film, many people don't notice it.

We started shooting. And disaster struck almost immediately. She began calling me 'Sir' in front of everyone else. I decided to speak to her about it. She was older than me, why should she call me 'Sir'? 'You are my director, and so I must call you "Sir",' said Mrs Sen. I told her in that case I too would call her 'Sir' henceforth. Following my lead the entire unit began calling her 'Sir'. Till the last day of her life that was how our equation remained. The Kashmir shoot schedule was a particularly memorable one. My daughter Bosky, Meghna Gulzar, was little then and Sir used to always play with her. Rakheeji had travelled with us too. We used to have these superb addas—Rakheeji, Sanjeev, Sir and I. Sanjeev and Sir had a great rapport.

The shooting got over. When we got our hands on the first rushes, a shadow seemed to descend upon the entire unit. No one

liked the film, not even Sir. But she could not say anything to my face, so instead she remarked, 'It's otherwise fine. But I'm sure there's more to be added. There'll be music as well.' I understood what she was saying. 'See, this is the film,' I told her, 'it won't become anything different or anything new.' My cameraman called me aside and asked me, 'See, whatever we watch in the news, why will someone want to go see it in a movie?' As in, to them the film will be no better than a detestable newspaper. I went back to the editing table and the final film managed to pique everyone's interest again. Everyone came away amazed by Mrs Sen's bravura performance and her screen presence.

Then it happened. I was in Moscow at that time, at the film festival there. *Aandhi* was on its twenty-second or twenty-third week in India, about to complete a jubilee. Out of the blue I received a call informing me that the film had been banned. Why? Some people had staged a protest carrying placards, etc. in south India: offended by a prime minister of India being depicted as drinking alcohol and smoking cigarettes on screen. Sadly, it was precisely that stereotype that I had wanted to break out of—that women other than those imagined as vamps in cinema also drank and smoked, that was all I had wanted to portray. Later, during a conversation with Shri I.K. Gujral, then minister of information and broadcasting, I found out that the aforementioned offence had not been the only issue, there had been other complaints as well. Such protests had prompted an anxious Sanjay Gandhi to request for a ban on the film. A big report was published in the *New York Times* on the ban. Sir, too, was very hurt by the whole incident.

However, no matter the fate of our film, our friendship was undamaged. I had heard so much about how she was very reserved, how she never socialized with people or even spoke to anyone. But I got to know the person very differently. Perhaps she had stopped appearing in public, but that did not mean she had stopped interacting with people. I used to go to see her whenever I visited Calcutta. Moon Moon had told me once that although she was not allowed to pass on telephone calls to her mother without informing her first, in my case all she had to do was pick up the phone and say 'Sir has called'. When it came to blessings, this was indeed a big one. In fact, I knew her as an extremely emotional and warm person. I remember how throughout the shoot of *Aandhi*, in all the emotional scenes where she was required to cry, not for once did she need glycerine. She only had one demand. I had to play two lines from the song *Tere bina zindagi se . . .* (Except you I have no other complaints with life . . .) on a cassette player. She would listen, and then a couple of minutes later ask me to take the shot. The two lines were *Tum jo keh do toh aaj ki raat chaand dubega nahi, raat ko rok lo . . .* (If you wish, the moon will not wane tonight, hold back the night . . .). So, throughout the shoot I had to carry around the cassette and my two-in-one player.

I remember the many times I have turned up at her place on Ballygunge Circular Road to be greeted by the sight of her sitting in the veranda and feeding grapes to crows. I used to be so astonished. The crows would take the grapes right from her fingers. I had always heard crows did not touch human beings! If I ever visited her in the morning, at some point in the middle

of our conversation she would call and ask someone to fetch me a glass of cold milk, much to my amazement each time. How did she manage to remember my breakfast menu even after so long! Many a time it happened, I was in Calcutta but could not manage to go meet her. Instead, I had called and spoken to her. All of a sudden, the very same evening, Barinda would appear at my door. From working as her secretary, Barinda had gradually become a family member. He would come and say, 'Madam is here with the car. Come.' I would immediately go and meet her.

I saw Moon Moon when she was only a little girl. I saw her daughters as children too. Even now we keep bumping into each other in flights or functions. Raima had visited me once to talk about her grandmother; they did a shoot as well. All my love and my very best wishes to them.

Tarun Majumdar

I have had the good fortune of being acquainted with many a dhoti–kurta-clad Bengali bhadralok gentleman. What I never imagined was how different this particular gentleman's acquaintance was going to be in my life. It was from him that I learnt the style of wearing a pleated and tucked starched dhoti. In fact, it was he who first introduced me to the poetry of Jibanananda Das. He was an inextricable part of Bengali life, just as he was a part of mine. Our Tanuda, director Tarun Majumdar.

I first met Tanuda through Hemantada. He had just made his film *Palatak* in Bengali, and it was a huge hit. So, he was in the middle of considering a Hindi version of the film. Hemantada called me one day and introduced us. Subsequently, I visited Tanuda's Calcutta office at New Theatres numerous times, where I also got to meet Manikda and Suchitradi. Back then New Theatres was one of the most happening places on the map of Indian cinema.

Work began on scripting and writing the songs for *Rahgir*. And I met Sandhyadi, Sandhya Mukherjee. An extremely lively

person, Sandhyadi used to always candidly speak her mind. For instance, while working on the script and the songs for *Rahgir*, the Hindi remake of *Palatak*, Tanuda had initially insisted that everything in Hindi be kept exactly how it had been in the Bengali original. However, since every language possesses its own style, keeping everything the same in translation risks compromising on the innate rhythm of a language. One day Sandhyadi said, 'You have asked him to do a ditto translation from Bangla to Hindi but that will undermine the rhythm of the Hindi language.' But Tanuda was convinced that was how he wanted things. Why? I had understood why. The essence of the Bengali original, the flavour that was captured in the original *Palatak*, all of it was innately Bengali, and any attempt to remould it to fit Hindi ran the risk of ruining its taste. I did try a lot too. Initially it had been decided that Anup Kumar was

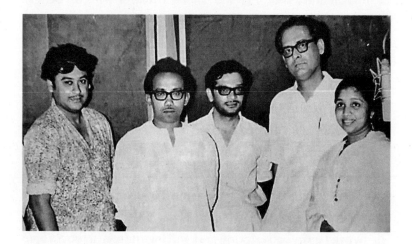

going to reprise his role in the Hindi remake and accordingly he and I even began rehearsals. Such a spontaneous actor he was! Wow! It was a delight to see him acting. Truly, back then there were stalwarts ruling Bengali cinema. Eventually he was not cast and when the shoot for *Rahgir* began in Bombay, somehow it failed to become anything other than just a Hindi film. Somewhere, the intoxicating nature of the Bengali original was lost. Of course, this is only my opinion.

But this tale is not just about stories of Tanuda and cinema. The true mystery lies elsewhere. Tanuda had a dusky complexion, as did Sandhyadi. But in this family of dark-skinned people, one fine day I came face to face with a very fair, light-eyed girl. Rakhee.

Rakhee was brought up by Sandhyadi. The acquaintance actually began at Hemantada's house in Bombay. I used to go there for work. Rakhee and two of her friends would steal my car keys and go out on drives. By steal, I mean they used to send word with Hemantada's driver that Jayanta, the latter's son, wanted to go out and my car, parked in front of his, needed to be moved. I would naively hand over the keys and they would be off, for paani puris one day or just for an outing on other occasions. Thank goodness for that!

Tanuda used to travel to Bombay quite frequently since Hemantada was the music composer for most of his films. Our friendship had deepened so much that Tanuda too was a regular at my tiny flat in Juhu. By then I was quite charmed by the fair Bengali girl. Consequently, I even learnt how to write love letters in Bengali. Although I was fairly well-acquainted with the

language since before my time with Bimalda, it was only after falling in love that I learnt to write it as well.

Tanuda would come over, take the *Sanchayita* off the shelf and keep reciting one poem after another. Sometimes he would sing Rabindra sangeet with full-throated ease. I used to consult the contents pages of the *Gitabitan* and select songs for him to sing, much to his astonishment. Perhaps he never expected me to have this amount of expertise in Bangla. Such is the splendour of love!

Although Tarunda and Sandhyadi could not attend our wedding, deep in my heart I am certain that ultimately they

were the ones who performed the *kanyadaan*. Even though the actual ritual during the wedding was performed by Sachin Dev Burman. But that fateful evening, during the golden hour when I had come face-to-face with Rakhee at Tanuda's house, I consider that moment as the true instance of *kanyadaan*. So what if it did not happen as per rituals! The girl they had adored and brought up with so much love, no matter when she got married or how, the true right of performing *kanyadaan* rested solely with Tanuda and Sandhyadi.

Even now, whenever I meet them, I bend over and touch their feet. They are my relatives after all! Not only is there a pull of the heart, but they also happen to be my in-laws.

I have met very few people who are as educated and polite as Tanuda. Besides, his deep love and devotion for Rabindra Sangeet has also forged a unifying link between us. My association with Tanuda has only served to enrich me. His light has illuminated my life immeasurably.

Sharmila Tagore

Rakheeji had once explained to me that no one had dimples on both their cheeks, dimples always formed on one cheek. I had taken her at her word. But I remember coming across Rinku, Sharmila Tagore, accepting a Screen Lifetime Achievement award once. She had dimples on both cheeks!

I know her since the poster of *Apur Sansar*, although we met much later. I recall seeing her drop by Mohan Studio to meet Tanuja. They were fast friends, sisters in arms. Tanuja was acting in Bimalda's film at the time and Rinku used to visit her on the set. Of course, back then I could not have dared call her Rinku. I was an assistant director, she was a leading star. With a leather bag dangling from her shoulder, she would walk in with such style that one probably felt they had to speak in flawless English just to talk to her. It only served to make me very nervous. However, I soon found out that it was not like that at all. She spoke Bangla and did so in a lilting tone with her head swaying. And yet, besides her glamour, she also possessed a certain gravitas which set her apart from everyone else. When I had watched *Apur Sansar*, it had never struck me as to how

sharp and intelligent a woman Rinku actually was. Had I not met her, I would have perhaps never known that such a graceful personality and such razor-sharp intellect could cohabit.

I had always wished to make a film with her. While making *Khushboo* I went to her with the request to appear in a small role. I took Basu Bhattacharya along with me; they used to be great friends. Rinku heard us out and agreed to do the guest appearance. It was now my turn to return the favour. I approached her with *Mausam*; she instantly agreed. For the first time the two of us really got to know each other. That was also when I found out that she was a crazy fan of Shammi Kapoor. While living in Calcutta she used to bunk college to catch his films. And after she moved to Bombay her first film was with the very same Prince Charming!

In *Mausam* Rinku had a double role, first as the mother and then the daughter. The mother calm and quiet, the daughter a feisty sex worker. The first day of the shoot, preparations were in full swing. All of a sudden, I was approached by Isa bhai, our sound-recordist. 'Rinku is having some trouble with her dialogue. If you can change that part a little.' The dialogue was: 'See saab, I will do whatever you ask me to, I will live with you . . . but I will not sleep with your friends . . .'. It was a frank sexual deal she was trying to strike with her customer, played by Sanjeev Kumar. I tried explaining it to Rinku that with that one line of dialogue, she was basically establishing the whole character. She was foregrounding a frank, unabashed woman along with her profession. Otherwise, the only alternatives were the hackneyed dialogues of Hindi cinema—'I don't sell my body, I only sell

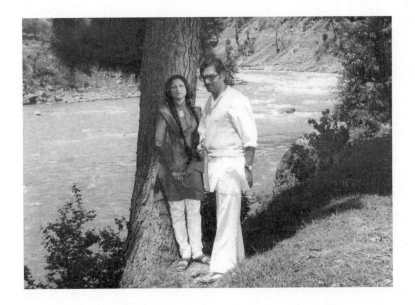

my voice'—all rubbish! Did that ever happen in real life? While I was explaining this to her, Sanjeev was nearby. Suddenly, he said, 'Rinku, you say these lines without any expression. You'll find it becomes much easier.' 'The things you say Haribhai!' Rinku exclaimed. 'How can someone speak without expression?' You will hardly believe it, but Sanjeev immediately proceeded to show us exactly how it could be done. He told her to say the lines while thinking about something else. After a few rehearsals with him, Rinku delivered the perfect shot. And confessed that she began to clearly comprehend her character from that very moment. She won the National Award for Best Actress for the role.

That shoot was an excellent time for all of us. Baba, as in Saif, was very little then and my daughter Meghna was around

two years old. They would play around the set. We used to continuously share our worries and observations about children. My closeness to her family dates back to that time. I used to call Tiger by his first name Mansoor. He would tell me, 'Gulzar, I keep getting reminded of my grandmother. Only she used to call me Mansoor.' But Mansoor was a strict father and Rinku too was extremely disciplined, calm and composed. Even if she were to scold someone, it was done in a manner that ensured the person understood their mistake but did not feel insulted in the process.

Rinku and I made only one other film. *Namkeen*. Before Rinku, the character was slated to be played by Rekha, but that did not work out. The shoot had already begun and many big artists had already blocked their dates—Waheedaji, Shabana, Sanjeev. I was staring at a catastrophe. I went to Rinku and said, 'You *have* to do this, you begin shooting tomorrow.' 'At least give me a day,' Rinku replied. The next day she came over to my place with Basu. 'See, Rekha was doing this. If I suddenly take over from today, my equation with her will be jeopardized. I don't want that.' 'Don't worry about it,' I reassured her, 'it was merely a professional fallout. Even my equation with Rekha will not be hampered, let alone yours.' But from that day onwards my respect for Rinku increased manifold. Without a word about the film, she had chosen to stay true to her profession instead—a woman who possessed a truly different nobility of spirit.

Rinku was of that rare breed of people who had come to accurately comprehend the true meaning of the word 'dignity'.